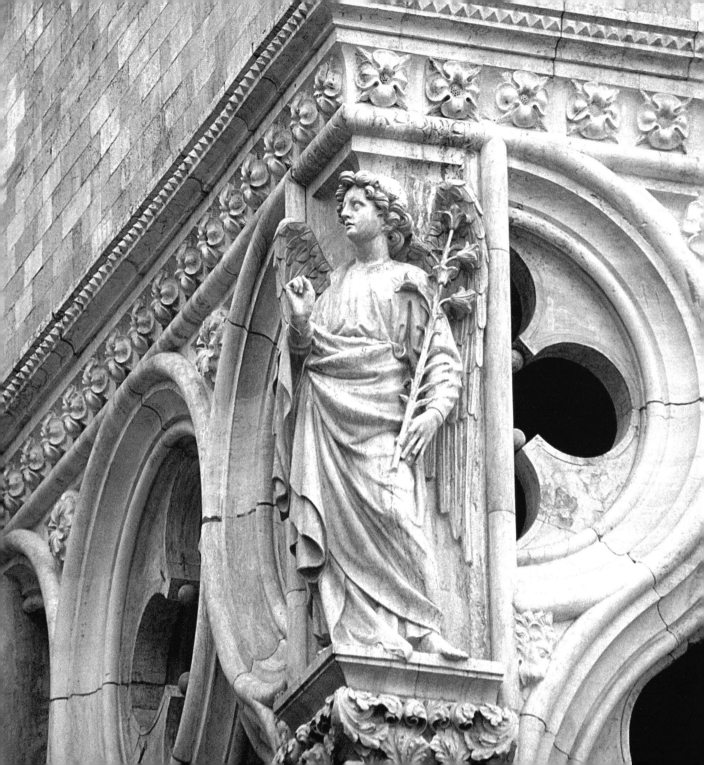

Outer
BEAUTY
Inner JOY

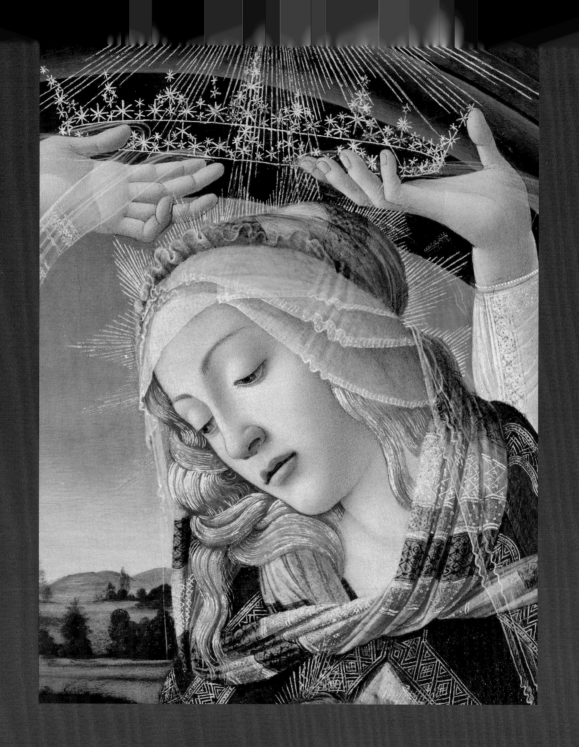

JULIANNE DAVIDOW

Outer
BEAUTY
Inner JOY

Contemplating the Soul of the Renaissance

Foreword by

THOMAS MOORE

Author of *Care of the Soul: A Guide for Cultivating
Depth and Sacredness in Everyday Life*

BUNKER HILL PUBLISHING

For my fellow travelers on the journey.

www.bunkerhillpublishing.com

First published in 2010 by
Bunker Hill Publishing Inc.
285 River Road
Piermont, New Hampshire 03779
USA

10 9 8 7 6 5 4 3 2 1

Library of Congress Control Number: 2010931627

ISBN 9781593730864

Published in the United States by Bunker Hill Publishing
Designed by HvADesign: Henk van Assen and Anna Zhang
Printed in Canada

FRONT COVER
Allegory on Water: Birth of Venus (1555)
Giorgio Vasari and Cristofano Gherardi
Apartment of the Elements, Palazzo Vecchio
FLORENCE

In this apartment, Vasari and Gherardi designed and painted
allegorical frescoes of air, earth, fire, and water with cosmologi-
cal, mythological, and astrological themes for Duke Cosimo I de'
Medici. Symbolically, the water element represents the source of all
life, purification, and regeneration. At the center, the fresco shows
the birth of Venus. As in the famous painting by Botticelli, the god-
dess appears on the half shell as she emerges from the ocean foam.

PAGE 2
**Madonna and Child with five angels
(Madonna of the Magnificat), Virgin Mary**
DETAIL
Sandro Botticelli
Uffizi
FLORENCE

PAGE 5
Venus and Cupid (CA. 1542)
FRESCO, DETAIL, ROOM OF OLYMPUS
Giovanni Battista Zelotti
Villa Godi
VICENZA

PAGE 7
La Primavera, The Three Graces (1477)
DETAIL
Botticelli
Uffizi
FLORENCE

PAGES 8 & 9
The Birth of Venus, Head of Venus (1486)
DETAIL
Botticelli
Uffizi
FLORENCE

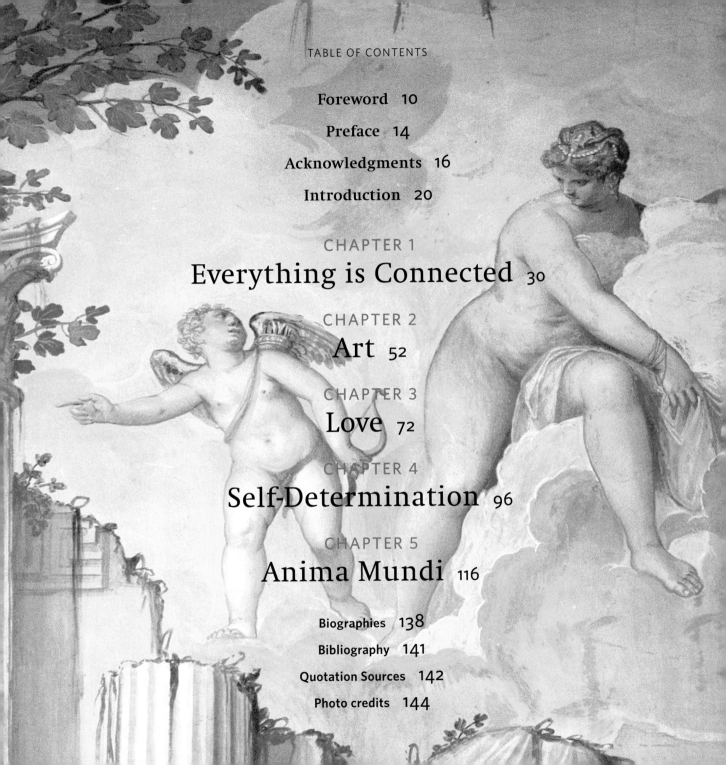

TABLE OF CONTENTS

Thomas Moore

An enchanted life has many
moments when the heart is
overwhelmed by beauty and
the imagination is electrified
by some haunting quality in
the world or by a spirit or voice
speaking from deep within
a thing, a place, or a person.

From: *The Re-Enchantment of Everyday Life*

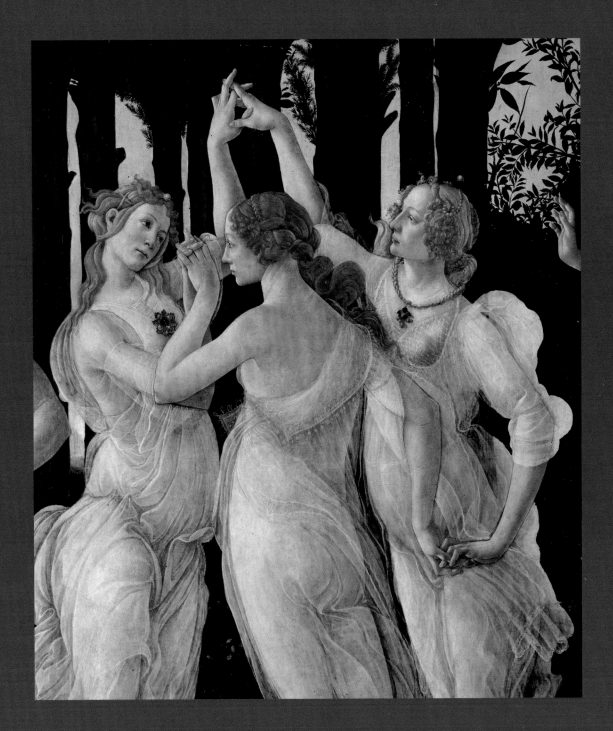

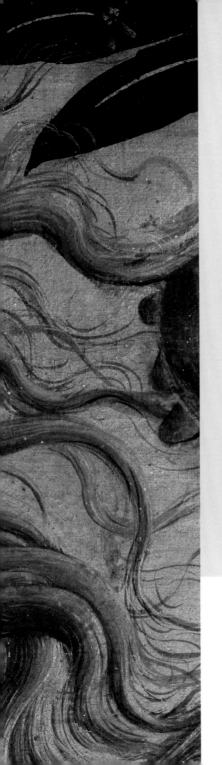

Regaining the memory of the true and divine beauty by the appearance of beauty that the eyes perceive, we desire the former with a secret and unutterable ardor of the mind.

Marsilio Ficino

From: *Meditations on the Soul:
Selected Letters of Marsilio Ficino*

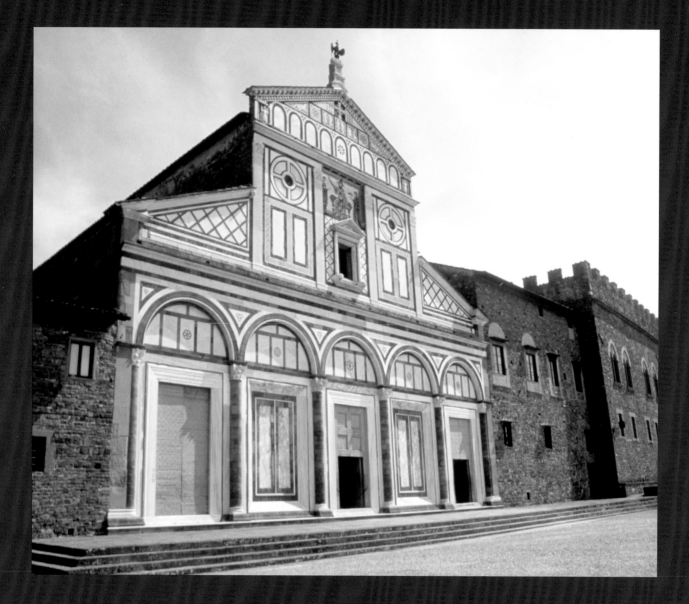

San Miniato al Monte

On a hill overlooking Florence stands the Basilica of San Miniato al Monte. A masterpiece of Romanesque architecture, the Basilica was begun in the eleventh century. The marble façade, completed in the thirteenth century, undoubtedly influenced Renaissance artists and architects in the creation of other great Florentine churches. Work on San Miniato continued over the centuries, and the Basilica contains some of the finest examples of Florentine Renaissance art.

Reviving The Renaissance

Thomas Moore

One of the most haunting and beautiful places I have been in is the Church of San Miniato that sits on a hill above Florence. It is full of mystery, beauty, and presence. By presence, I mean that you feel you are in a special place, set apart from ordinary reality, connected to that which is more than human. You can't separate the beauty you see from the air of divinity you perceive with your senses.

This is a theme that Julianne Davidow develops in this immensely attractive and important book. She shows in visual images, words, and description, a point of view that has been utterly lost to the modern mind: the idea that divinity and humanism go together. This means that to be a fully human person, developing all your latent abilities and points of character, you have to be in contact with that which is beyond you, the profound and visionary mysteriousness of your situation.

Renaissance writers, especially those quoted in this book, recommended both a courageous and imaginative development of your human abilities, and an intelligent, whole-hearted participation in the mysteries that affect you. They urged both humanism and a certain kind of religiousness or spirituality. In many cases, as for Marsilio Ficino and Pico della Mirandola, that spirituality drew from

several spiritual traditions and also aimed at reconciling ancient paganism with the Christian world in which they lived.

Here are two important lessons that we can learn from the Renaissance inner adventurers: never separate the worldly from the spiritual, and never define your current spirituality as more valid and valuable than the paganism of old. In particular, paganism contains the values of the primacy of beauty and affection for the natural world that were lost when a certain kind of Christianity triumphed. To the extent that we have allowed commerce and industry to render beauty irrelevant to our cultural environment, and to threaten the health of our planet, we are still suffering the division of a pagan sensibility from our formative philosophy. Look at the beauty in these pages, and you will get a taste of what we could be enjoying in the world around us today if we took our Renaissance teachers to heart.

People like Giordano Bruno, Pico, and Ficino, had a very sophisticated idea of God. When you read of God in their statements, you should know that they were steeped in the mystical writings of Dionysius and others who spoke of God as that which cannot be known or described adequately in our anthropomorphic ways. They were thinking of the unknowable, the mysterious, and yet the most intimate source of life. If you allow these writers the sophistication due to them, you will appreciate the power of this book. Otherwise, the danger is that you will see it as yet another travel book or picture book for the coffee table. To me, this book could be a manual of spirituality. It contains a point of view, now lost, that could save us from self-destruction.

Therefore, I would urge the reader to read the book carefully. Think about the words you read and take time with the images. There is the possibility for new life here, for finding a way out of the dehumanizing philosophies that control our world. As the Renaissance writers themselves said, it is valuable to bring new life to culture by learning from the past. Just as they learned from, and didn't just copy, the Classical Period, we could learn from them how to create our own cultural Renaissance.

There is no reason why we could not appreciate the wisdom and beauty of that brief period in European history called the Renaissance, and be inspired toward a rebirth of the human spirit in our time. We have passed through a remarkable epoch of physical discovery and technological advance. I have no doubt that the Renaissance masters cited in this book would have been overjoyed to witness the achievements of the twentieth century. But it is time to move on and focus on those things we have neglected, especially art and beauty, the union of humanism and religion, and making a culture in which our best human efforts join with an infinitely potent spiritual vision to create a world in which human beings thrive, not just physically, but in soul and spirit as well.

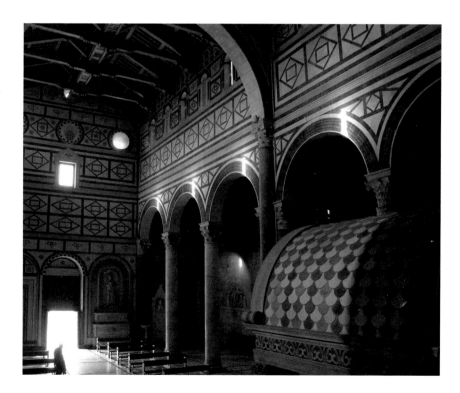

San Miniato al Monte

The tabernacle (foreground right) was designed by Michelozzo in 1448. The external part of the tabernacle roof, in enameled terracotta, is the work of Luca della Robbia.

PREFACE

The first time I came to Italy, I arrived in Venice on a sunny September day and stepped out of the train station into another world. The usual street vendors were displaying their wares, and swarms of tourists surged along the streets and in the squares. But this scene from daily life was unfolding against a backdrop of sparkling waterways and buildings of unbelievable beauty. The art and architecture of the place leaped out at me. I screened out the tourists and began to absorb the ancient vibrations of the city.

So began my Italian 'second life.' I found myself returning to Italy again and again, with shorter periods between trips. The continued exposure to the ancient sights impressed themselves in my mind, working a kind of slow alchemy, drawing me deeper into the contemplation of their forms and essence.

Eventually I began to delve into the writings of the Renaissance, for it was primarily the work of this period that compelled me. Perhaps I was inspired by the courage of the artists who broke from dogma, and in returning to the study of the past, found a new freedom of expression. They studied the wisdom of ancient esoteric traditions that said love and beauty could be a route to divine insights. They wanted to act as a conduit for the all-originating Source they believed in, to bring an immaterial substance into form. Thomas Moore, in his *Care of the Soul,* speaks of the Renaissance artists, theologians, and merchants who "cultivated a concrete world full of soul. The beauty of Renaissance art is inseparable from the soul-affirming quality that tutored it."

I realized that in order to fully appreciate the work of Renaissance artists, it would be important to enter into the essential impulse that inspired their creations. And I also realized that through viewing these works, it would be possible to become transformed by them. The artists brought the qualities of harmony, proportion, order, and a unique beauty or grace into their productions. What new essence can seeing and absorbing the energy from these old creations bring to an individual's life? I think it's possible to find, in the Italian Renaissance writings and art, a way to initiate a Renaissance in one's own life.

Miracle of the Sacrament

FRESCO, DETAIL
GIOVANNI PICO DELLA MIRANDOLA (MIDDLE),
MARSILIO FICINO (LEFT), AND ANGELO
POLIZIANO (RIGHT)

Cosimo Rosselli
Basilica of Sant' Ambrogio
FLORENCE

Pico and Poliziano were two of the greatest Renaissance
philosophers who gathered around Marsilio Ficino,
head of the Platonic Academy of Florence.

In making *Outer Beauty, Inner Joy* I was following my inner driving force, or *daemon*, as Plato called it. Working with these words and images helped connect me with the energy of the writers and artists presented here. I hope this book will be a springboard for those wishing to explore more deeply the art and literature of this time and place, taking the best of what the Renaissance had to offer, and incorporating it into their own lives. The subject of the Italian Renaissance is vast, its story complex, and I am focusing here only on a few elements that have impressed themselves upon me. There are many more players in this story who have not been included. This book is simply a brief encapsulation of the way I've understood what I've been reading and discovering, but the depth of knowledge to be found in this subject continues for me without a visible end in sight. These pages are only a dip into the Renaissance, one which may lead the reader to a longer and more profound immersion, and one that I think can be beneficial in reawakening a part of ourselves that may have grown dormant in the modern, technological world. I believe that the only way to deal with the immense problems we face today will be through recognizing the union of the material and spiritual worlds, cultivating tolerance for all great spiritual traditions, and deepening our connection to each other and to the planet.

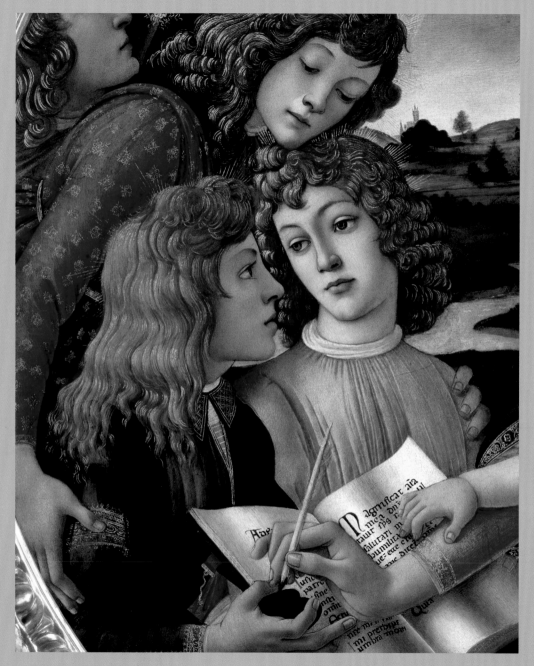

Madonna of
the Magnificat
(CA. 1483)
DETAIL

Sandro Botticelli
Uffizi
FLORENCE

ACKNOWLEDGMENTS

There are many people I need to thank: Ib Bellew and Carole Kitchel Bellew at Bunker Hill Publishing for their enthusiasm and wise counsel; Henk van Assen, together with Anna Zhang, for the exceptionally beautiful design which has truly made the book come alive; Thomas Moore for his book, *Care of the Soul,* which first introduced me to Marsilio Ficino, and for his inspiration and continuing support; Ralph White and the New York Open Center for their conference in Florence in 2000: The Italian Renaissance and the Esoteric Traditions, where I had the good fortune to hear many outstanding scholars and to begin to learn more about Ficino and his Platonic Academy, as well as for their many other conferences, classes, and workshops; Marina Baruffaldi, who always has room for me in her wonderful home in Venice, for looking, reading, and commenting; Maria Ranaldi Liebhauser and her family for more reasons than I can name, and renowned artist Renato Ranaldi for taking me around Florence and showing me some of its 'hidden treasures;' Giuliano Burroni who accompanied me around Venice, tripod in hand; photographer Paul Coughlin who saw in my rough presentation what this book could be; Robert Place for his guidance; Jacopo Fasolo and Grace Franzoi for their observations and comments; Tom Worrel for his careful reading and corrections; and distinguished scholar Marino Zorzi for reading the text for accuracy and helping me with historical information. Many thanks as well to Jennifer Belt of Art Resource in New York and to the staff of the Marciana Library in Venice. Of course, any errors that may be found in these pages are mine.

I would also like to thank Sarah Barnaby, Jacqueline Davidow, Joie Davidow, Victoria Haberman, and Leide Porcu for helping in so many ways when I've been in Italy as well as in the States; and Serena Cipolletti, Grace Jeffers, Charles Isherwood, Cristina Lanza, Ellen Perecman, and Alice Rosengard for their invaluable assistance in the completion of the book.

To all my family and dear friends, for your support and helpful suggestions, a heartfelt Thank You.

—*Julianne Davidow, April 16, 2010, Venice, Italy*

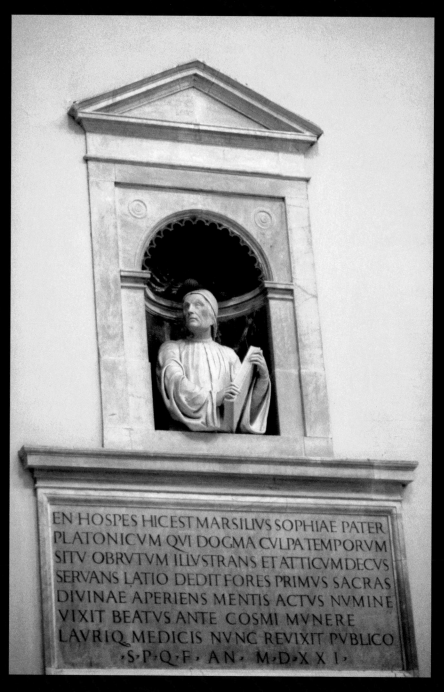

Bust of Marsilio Ficino

Andrea di Piero Ferrucci
Basilica of Santa Maria del Fiore
FLORENCE

HERE, VISITOR, IS MARSILIO, THE FATHER
OF WISDOM, WHO, BY CLARIFYING THE
PLATONIC TEACHING, WHICH HAD BEEN
COVERED BY DUST BECAUSE OF TIME GONE
BY, AND BY PRESERVING THE GLORIOUS
GREEK TRADITION, PRESENTED IT TO THE
LATIN WORLD. WITH A GOD'S HELP, [HE
WAS] THE FIRST PERSON WHO OPENED THE
SACRED DOORS OF THE DIVINE MIND, AND
HE ONCE LIVED HAPPILY, BY THE GREAT
GENEROSITY OF COSIMO AND LORENZO DE'
MEDICI. HE NOW HAS COME BACK TO LIFE
THANKS TO THE PUBLIC GENEROSITY OF
THE SENATE AND THE PEOPLE OF FLORENCE.

IN THE YEAR OF OUR LORD: 1521

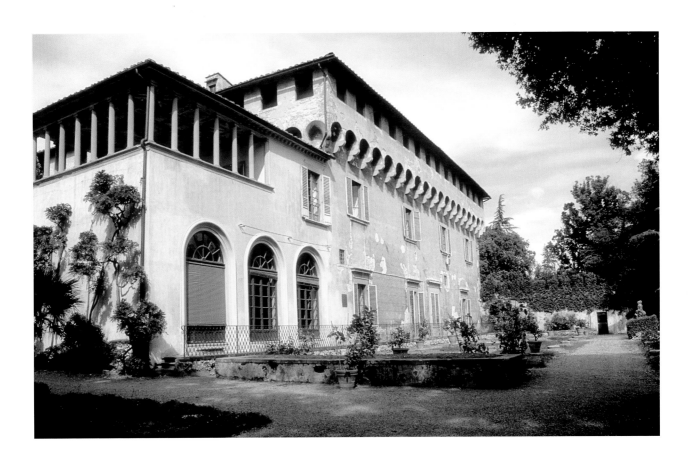

Villa Medici di Careggi

This fourteenth-century villa on the outskirts of Florence was redesigned in the fifteenth century according to a plan attributed to Michelozzo. Here, Cosimo de' Medici created his Platonic Academy with Marsilio Ficino as its leader.

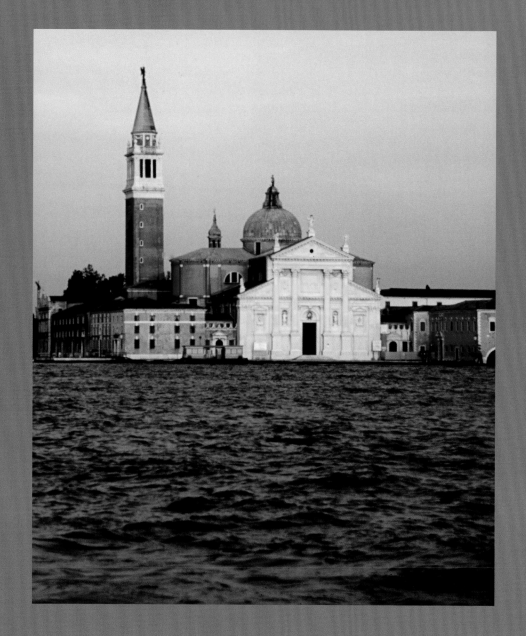

Church of San Giorgio Maggiore (1559–1580)

Andrea Palladio
VENICE

Introduction

Julianne Davidow

W henever I'm in Italy, I like to pretend to time travel and imagine living during the Renaissance. It's not very difficult to do in Venice, as I look across the Grand Canal to the Church of San Giorgio Maggiore at sunset, with the sky an azure blue; or in Florence, as I'm walking in the Boboli Gardens at closing time and there's no one around; or in a Palladian villa in the Veneto, losing myself in a fresco of the gods at home on Olympus, the Greek mountain once thought to reach the heavens.

When I see the art and architecture of the Renaissance, still very much alive in Italy today, and when I read the words of the men and women who lived at the time, I sense the presence of the writers and artists themselves. The energy of their thoughts and creations still reverberates, and I feel surrounded by the same spirit that infused their lives. I find myself in a transformed world—one in which nature, art, and the written word all partake of a common essence, the *Anima Mundi* Renaissance philosophers spoke of, the Soul of the World.

Divine Providence brought our world into being as a truly living thing,
endowed with soul and intelligence . . . a single visible living thing, which
contains within itself all the living things whose nature it is to share its kind.
FROM PLATO'S *TIMAEUS*

In Italy, I usually have a camera in hand, and one thing or another continually pulls my attention: light falling through a rosette window, an ornately carved wooden door, sculpted figures perched atop the columns of a building. I tend to agree with Petrarch, often called the father of Renaissance Humanism, and known for his tireless search of ancient texts, in feeling more inspired by the ancient world than by the one in which I was born. Whenever I start fretting about the state of the world, environmental problems, threats of war and destruction, I think first, of course, about the future of all the children. Then I think about the past—about the art and architecture that is hundreds, even thousands of years old.

The Italian Renaissance holds a particular fascination for many. It was a time of optimism about what was possible, and of intense growth and expansion—in education, art, science, commerce, literature, and philosophy. A part of this expansion was a curiosity to learn more about other cultures and spiritual traditions. Ancient wisdom, especially from Rome, Greece, and Egypt, spurred Renaissance thinkers to reimagine the way they perceived themselves and their part in the universal scheme of things.

When I started to understand the link between what people were writing during the Italian Renaissance and the images I was capturing with my camera and seeing in books and museums, I wanted to combine them, for they belong together. This book is about making the connection between the words of Italian Renaissance writers and the physical manifestation of those words: Art and architecture created during the fourteenth, fifteenth, and sixteenth centuries. It is the marriage of form and content. Of course Italian cities are made up of architecture from all its historical periods. In many cases, buildings were continually worked on over centuries. But *Outer Beauty, Inner Joy* focuses on the art and inspiration of that time broadly called the Renaissance. The placement of words with specific images was done imaginatively, as I found similar themes in each pairing.

Italian Renaissance thought and creations blossomed from two lines of influence, Humanism and Neoplatonism, which at times overlapped. Humanism grew out of the recovery of Latin texts—literature from the time of the Roman Civilization. In texts retrieved from monasteries, where they'd been hidden away

during the dark ages, scholars found that classical literature could act as a guide for earthly life, that language could be used to express the individual's experience. These scholars wanted to seek the truth by study and personal reflection, rather than by following religious dogma.

Neoplatonism is a term, coined in the nineteenth century, for a school of philosophy based on the works of the Greek philosopher Plato, who lived in the fifth century B.C., and expanded upon by those who followed in his footsteps. Plotinus, who lived in Alexandria and Rome in the third century A.D., is considered the first of the Neoplatonists. He was followed by others, including his disciple Porphyry, who lived in Athens and Rome in the third century A.D.; Iamblichus, a disciple of Porphyry, who lived in Rome and Syria in the third and fourth centuries A.D.; and Proclus, who lived in Athens in the fifth century A.D. While Plato's ideas were familiar to scholars in Italy during the fourteenth century, through the *Timaeus,* the writings of St. Augustine, and from Arabic philosophers whose work had been translated into Latin, it wasn't until later, during the fifteenth century, that extensive manuscripts from the Platonic tradition were brought into Italy from Greek Byzantium. During the Middle Ages, a more naturalistic and concrete outlook had prevailed, based on the empirical approach of Aristotle. But with the rediscovery of Platonic and Neoplatonic texts, mysticism took precedence.

In the latter part of the fourteenth century, Humanist Coluccio Salutati, who was then Chancellor of Florence, played a major role in having the Byzantine classical scholar Manuel Chrysoloras appointed to teach at the University. Under the influence of Chrysoloras, a group of Humanists already familiar with Greek literature led the way to the later development of interest in the works of Plato.

During the 1430s, the city of Constantinople, capital and last stronghold of the Byzantine Empire, and seat of the Eastern Orthodox Church, was being threatened by the Ottoman Turks. The Emperor, John VIII Palaiologos, hoped that if the 400-year-old schism between the Eastern Orthodox and the Western Latin branches of the Catholic Church could be healed and their differences resolved, he could get the help of the West against the Turks. To this end, in 1438 an ecumenical council was convened in Ferrara, which was later transferred to Florence. As a result, the

Emperor of Constantinople and a great number of Byzantine scholars arrived in Italy, bringing their knowledge with them.

Two of these scholars in particular proved to be major catalysts in the spread of ancient knowledge from East to West. One was George Gemistus Plethon, the most celebrated Neoplatonic philosopher of the age. He spoke to Florentine humanists on the subject of the difference between Aristotle and Plato, thereby arousing interest in the works of Plato. Word spread of his beliefs and expertise, inspiring Cosimo de' Medici, founding father of the ruling Medici family, to eventually create his own Platonic Academy in Florence. One of the greatest influences on the development of Renaissance philosophy, Plethon believed that it was only through fully participating in life, above all in society and politics, that the scholar or sage could help to shape history.

Bessarion, a student of Plethon, and one of the most outstanding scholars of the time, had an even more important impact in the West. He felt that the great philosophical systems of antiquity were in accordance with Christian doctrine, and that peace could come from religious tolerance. Bessarion was made a Cardinal by Pope Eugene IV in 1439, and settled in Italy, where he wrote, taught, and helped other Greek exiles.

Although the major differences between the Eastern and Western branches of the church were resolved at the council, the Greeks in Constantinople later rejected the agreements. And when Constantinople did eventually fall to the Turks in 1453, Bessarion, wanting to preserve Greek culture, took possession or copied every book and manuscript he could. In 1468, he donated his books to the Republic of Venice. By 1537, Venice had begun to construct a library to house these works, the Library of St. Mark's (now the Biblioteca Nazionale Marciana) designed by Jacopo Sansovino. Today the library is one of the most important repositories of classical texts in the world.

With the fall of Constantinople, many more Greek scholars fled to Italy, where Italian Humanists welcomed their scholarship and teachings. For Renaissance philosophers, Plato had discerned the fact that each person could come to know the truth about him/herself, that the living essence of the Divine

could be found within each individual. In Neoplatonic thought, the universe exists in levels, and the highest is one Source, 'the One.' The One emanates, or continually issues forth, the lower levels, culminating in this world. The essence of the One can be felt through the *Anima Mundi,* the World Soul, which is present here on earth, moving in and through all.

Cosimo entrusted Marsilio Ficino, the most influential Neoplatonic philosopher (also a doctor, theologian, linguist, and astrologer) of the Italian Renaissance, to translate Plato's complete works, as well as the *Corpus Hermeticum,* into Latin. The *Corpus Hermeticum* is a group of ancient Greek texts, which Ficino believed to be the common source of both Platonism and Christianity. Ficino and his colleagues wanted to harmonize thought systems, by seeking the common thread in all the philosophies they studied.

For Ficino, the beauty of the visual arts could serve as a valuable reminder of the soul's home in the absolute beauty of the divine world. His teachings became widely diffused into society and affected the works of many great artists including Botticelli, Raffaello, and Michelangelo. According to the Renaissance theory of art, sculpture was said to mimic divine creation. One of the most famous Renaissance sculptures is Michelangelo's *David*. The great artist worked under the premise that the figure already exists in the stone, waiting to be discovered, just as the human soul is said to exist in the body. "I saw the angel in the marble and carved until I set him free," he is quoted as saying. Through the belief that the world is a living being with a soul, the *Anima Mundi,* and that this soul could be perceived through the use of imagination, in the sense of putting sense impressions into visible form, an artist's work was to reveal what was intrinsic in the material itself.

Humanism developed into civic Humanism, which encouraged the individual to be of service to the community. Neoplatonism said that each person's life plays an important part in the workings of one divine universe; Hermetic texts said that one of the purposes of the individual life is to make the world more beautiful, thereby completing God's creation. These ways of thinking inspired artists to create, writers to compose eloquently, and patrons to support them in their endeavors.

Artists acquired the freedom to paint and sculpt the body in a way that allowed it to be at once fully human yet infused with a divine perfection. They filled their creations with meaning, combining Christian and pre-Christian symbols. Cities became works of art, reflecting favorably back on their citizens.

Outer Beauty, Inner Joy is a synthesis of Italian Renaissance art and the thoughts and ideas of the cultural environment from which it was born. Opinions differed on how to interpret and integrate the ancient works that had become newly available. The philosophical trend of the Renaissance in Italy was one of inquiry, study, reflection, and dialogue. This book offers some ideas from ancient sources, filtered through the lens of Renaissance writers, combined with a small sampling of the resulting art and architecture.

As Renaissance writers and artists looked back to the 'golden age' of Greece and Rome for their inspiration, I look back to the Renaissance. I hope the reader too will find a connection—not only with the words and pictures presented here—but in recognizing that the wisdom, freedom, and tolerance they contain is a part of our heritage.

David (1504)

Michelangelo
Accademia
FLORENCE

This seventeen-foot statue represents the biblical King David as he contemplates his upcoming battle with Goliath. With his youthful strength and courage, this David served as a symbol of the Florentine Republic, and once stood outside the Palazzo Signoria, later called the Palazzo Vecchio, the seat of government at the time. It was subsequently moved into the Accademia Gallery, and a replica now stands in its place.

Several other artists had already tried to carve the block of marble that eventually became David. Michelangelo believed that some artists had a great capacity, called *intelletto,* to perceive the harmony and beauty inherent in the raw materials, and that others did not. Since Michelangelo possessed this ability, he was able to envision the statue before it emerged from the stone. He wasn't interested in presenting the body naturally, but ideally, as something finer than anything that could be found in the material world.

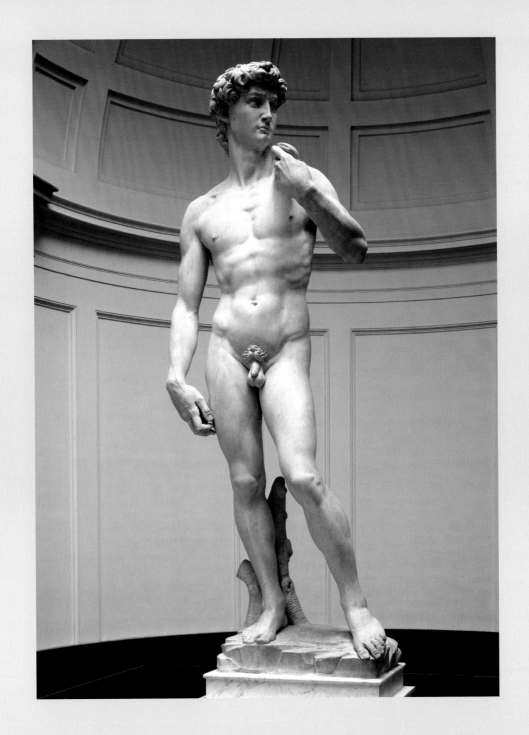

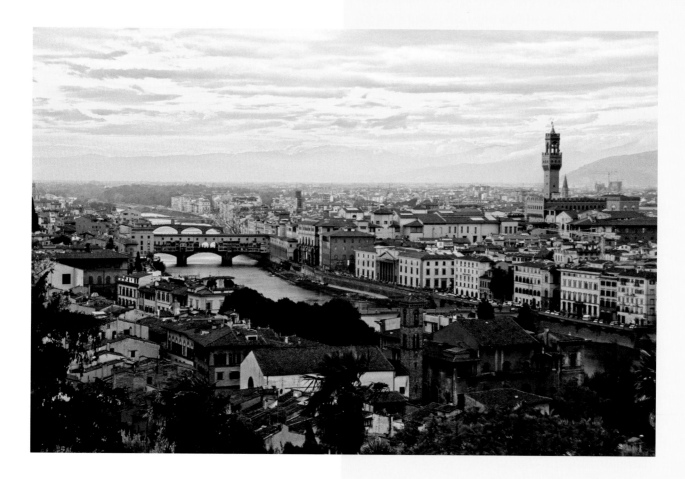

The River Arno and the Bridges of Florence

The bridge in the foreground is the Ponte Vecchio, followed by the Ponte Santa Trinita and the Ponte alla Carraia. The Ponte Vecchio, an ancient bridge rebuilt in 1345 by Taddeo Gaddi, was the only one of these bridges not destroyed during World War II. Above the shops on this bridge is the Vasari Corridor, built in 1565, and named after its designer, Giorgio Vasari.

One evening I left the Church of San Miniato al Monte, a soft light flowing in through its windows—lending the place an even more enchanted atmosphere than usual. I walked down the hill to the Piazzale Michelangelo to take the bus back to Florence. Here I received the gift of this sunset, casting a golden light over the city, as if the gods were smiling upon everything in sight.

If we are to call any age golden, it is without doubt this age, which brings forth golden talents in different places. That such is true of our age, he who wishes to consider the illustrious discoveries of this century will hardly doubt. For this century, like a golden age, has restored to light the liberal arts, which were almost extinct: grammar, poetry, rhetoric, painting, sculpture, architecture, music, the ancient singing of songs to the Orphic lyre, and all of this in Florence.

Marsilio Ficino

In Greek mythology, Orpheus played the lyre (a stringed instrument of the harp class), and his playing was said to animate and charm all of nature. Ficino is referring to the *Orphic Hymns*, ancient Greek poetic compositions to the deities, which he himself translated. They were believed to lead the listener from a state of everyday consciousness to one of a spiritual view of reality. Orpheus's lyre is a symbol for the harmony of the cosmos, uniting the physical with the spiritual.

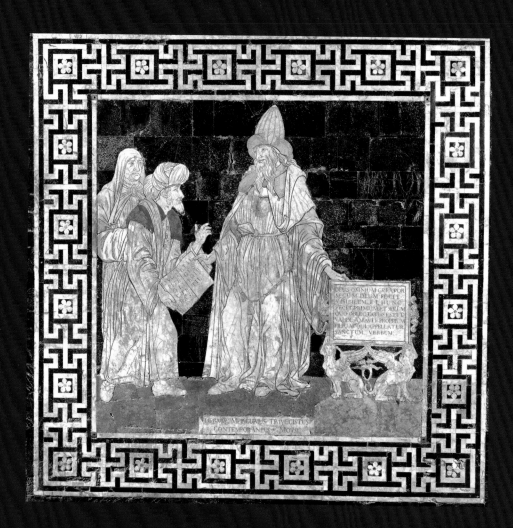

Hermes Mercurius Trismegistus:
Contemporary of Moses (1482)

MOSAIC FLOOR, DETAIL
Attributed to Giovanni di Maestro Stefano
Siena Cathedral
SIENA

Hermes Trismegistus, which means Thrice Great Hermes, was said to be an ancient sage, perhaps human, perhaps divine, who had discovered the truths of existence. He is a syncretic combination of the Greek god Hermes and the Egyptian god Thoth, both of whom represented writing and magic. The widespread acceptance of Hermes Trismegistus and the Hermetic writings during the Renaissance is evident in the placement of this image, which forms a part of the intricate, inlaid marble mosaic floor of the cathedral.

1

Everything is Connected

Renaissance Neoplatonists found similar ideas in the ancient texts they studied and incorporated them into their syncretic philosophy. Of particular importance was the *Corpus Hermeticum,* a group of Greek texts that agents working for Cosimo de' Medici had brought into Italy in 1460. Hermeticism originated in ancient Egypt and included a belief in astrology and alchemy.

> *True, without error, certain and most true; that which is above is as that which is below, and that which is below is as that which is above, for performing the miracles of the One Thing ...*

The above quote is from the *Emerald Tablet,* a Hermetic document that had already arrived in Italy and been translated into Latin by the twelfth century. "As above, so below" is also a principle from the Jewish mystical tradition of Kabbalah, which teaches the concept of reciprocity: whatever a person does on earth affects events on other, higher planes of existence, and whatever happens on higher planes affects events on earth.

Medieval and Renaissance alchemists based their work on Hermetic principles and tried to change one metal into another in the wider goal of learning about the spiritual nature of the material world. Since the material and spiritual worlds were believed to be aspects of the same truth, by deciphering the secrets of one, it could be possible to learn more about the other. Alchemy was both a chemical system of transforming the elements and a mystical philosophy concerned with the spiritual development of the soul. Through the law of correspondences, it was believed that the outer work of chemical transmutation could awaken an inner awareness and attunement with the higher self, the source of all knowledge.

During the Renaissance, philosophers considered the Hermetic writings to be the work of one man, an ancient Egyptian sage called Hermes Trismegistus. They placed him as a contemporary of Moses, and in an unbroken line of philosophers from Zoroaster to Plato. Hermes Trismegistus, which means "Thrice Great Hermes," comes from the name of the Greek god Hermes, whose attributes include wisdom, knowledge, and eloquence. Hermes is the Greek name for the Egyptian god Thoth, who is said to have given the ancient world myths revealing the truths of existence. Thoth was also said to be a mortal, who had attained immortality through self-purification, and who could act as an intermediary between the divine and human worlds.

In fact, the *Corpus Hermeticum* was composed in Alexandria during the second and third centuries of our era. Capital of the Hellenistic world, Alexandria was a multi-cultural metropolis where followers of Eastern and Western belief systems coexisted, and the *Corpus* contains elements from the Egyptian, Greek, and Judaic traditions. Inspired by Hermes, writers signed his name to their works.

Cosimo de' Medici (1389–1464), an ardent humanist with a great interest in ancient wisdom, sponsored the recovery of many texts from monasteries in Italy and from the East. He also allowed Jewish scholars, who had fled religious persecution in Spain and Portugal, to find a place of refuge in Florence under his rule—thereby allowing the scholastic diffusion of their philosophical traditions as well.

Cosimo eventually established a Platonic Academy at his villa in Careggi, outside Florence, with Marsilio Ficino (1433–1499), as its head. Here, Ficino translated Greek texts into Latin, and wrote commentaries, as well as his own philosophical works. He wanted to integrate ideas he had found in Plato, Neoplatonic writings, and the *Corpus Hermeticum,* which expressed a belief in the immortality of the soul and a longing of the soul to return to its divine source, with Christianity. Among the ancient Greek texts Ficino translated were the *Orphic Hymns,* poetry composed during the Hellenistic period. These poems had been used in spiritual rites and purification rituals. The mythological figure of Orpheus was sometimes said to be a priest of the Greek god Dionysus (who later became the Roman god Bacchus), who represents intoxication, transformation, and generation. With his music, Orpheus could bring beings to a state of ecstatic divine consciousness. Ficino set his translations of the *Hymns* to music and played them with other members of the Platonic Academy in Careggi. Ficino felt that by performing the *Orphic Hymns,* an individual could be brought into alignment with the harmonic frequencies of higher realms. But to reach these higher realms, it is necessary to first reach down to the depths of our soul, to the underside of life, to death itself.

Of all the myths about Orpheus, the most famous is the one in which he descends to the underworld to search for his wife, Eurydice, who has died after being bitten by a snake. He is allowed to return above to the world of the living, on condition that he doesn't try to look at her until they arrive. But Orpheus can't resist and when he turns, he sees Eurydice disappearing back into the Underworld. Although he loses his wife, he has experienced the ability to converse with gods and spirits, and attains the knowledge that the soul is immortal. The god Hermes guides Orpheus to the Underworld, and these two are intimately connected as intermediaries between the earthly and the spiritual worlds, between life and death.

In Hermeticism, Neoplatonism, and Kabbalah, as in the writings of Ficino, the human soul holds a central and important place. The *Corpus* speaks of a god

within that animates the body and connects the individual with the heavenly spheres. Every natural thing is infused with a divine essence. Ficino taught that through Eros, or love, which instills in us a desire for wholeness, and with the powers of thought and meditation, an individual soul has the ability to return to a state of conscious unity with the Divine.

Egyptian, Judaic, and Greek philosophies speak of the unifying principle of the macrocosm and the microcosm: As above, so below. Similar traits are said to be repeated through all levels of reality. Greek mathematician and philosopher Pythagoras taught the 'divine proportion,' a formula showing that all things are governed by the same mathematical law.

Among the many artists whose work was influenced by Ficino and the Platonic Academy is Leonardo da Vinci. Leonardo's drawing, the *Vitruvian Man,* is named for the Roman architect Vitruvius, who based his designs on the proportions of the ideal body. Here Leonardo illustrates that the human form reflects the greater form of the cosmos. There are five elements, five senses of physical perception, five geometrical regular solids, and the human body here makes a five-pointed star. In the Pythagorean tradition, the circle represents the spiritual world, and the square, the material one. So in this drawing, the body can be seen as a union of spirit and matter, and is a microcosm of the universe

Vitruvian Man (CA. 1492)

Leonardo da Vinci
Accademia
VENICE

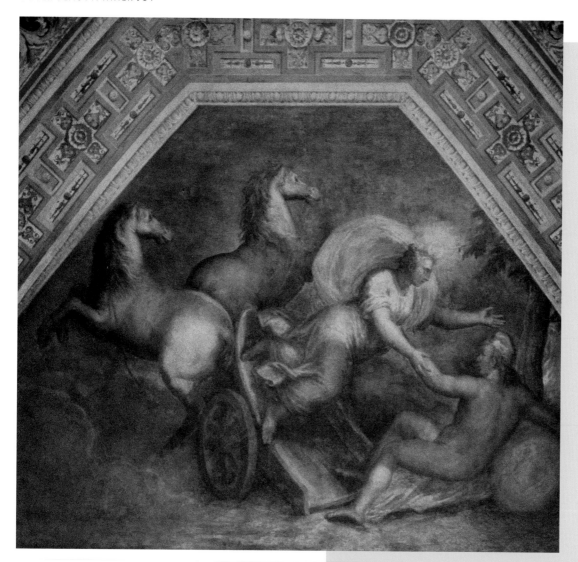

Allegory of 'Day' (BEGUN IN 1574)

THE CHAMBER OF DAWN, APARTMENT OF THE MIRROR

Sebastiano Filippi and Ludovico Settevecchi
The Estense Castle
FERRARA

The Estense Castle in Ferrara was the seat of power for the Estense family, who dominated Ferrara and its territories from the second half of the eleventh century until 1598.

36

Marsilio Ficino

At every person's birth, he or she is assigned a certain daemon by his own star, a guardian of life to help with his destined task.

When I saw this image, I couldn't help but imagine that the woman on the chariot was waking the man not only to a new day, but to life, offering him a helping hand, and giving him strength and courage as he takes on the duties that his destiny will prescribe.

According to the law of correspondences spoken of in alchemy and in the Hermetic tradition, all of creation is united in similar patterns. A birth welcomes a new life, just as a new day can be a new beginning.

The Labours
of the Months
[JULY]

(EARLY SIXTEENTH
CENTURY)

Bonifacio de' Pitati
National Gallery
LONDON

If you are born with a healthy mind, the stars will offer you some kind of appropriate career and lifestyle. So if you would like the heavens to be kindly, you should take up this work and this way of life. Go after it passionately, and the stars will bless your efforts.

Marsilio Ficino

The whole universe is an individual . . . like a person. And though all of its parts were created by God with a common purpose, each part has its own particular purpose In the same way, each person in the world can be happy when they accomplish the task they were designed for by the supreme craftsman.

Leone Ebreo

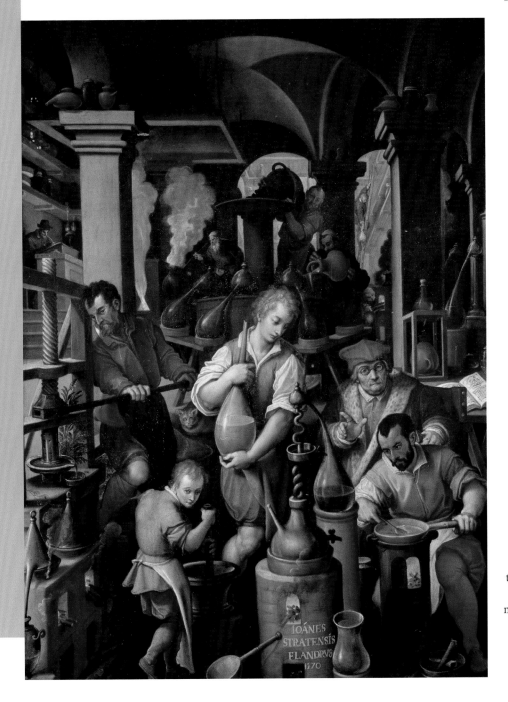

The Alchemist (1570)

Giovanni Stradano
Studiolo, Palazzo Vecchio
FLORENCE

The Studiolo, a small, barrel-vaulted room filled with paintings and rare objects, was commissioned by Francesco I de' Medici, Grand Duke of Tuscany, and was completed between 1570 and 1572. The Duke spent hours here pursuing his interests in alchemy and chemistry. The bearded man in the lower right-hand part of the painting is most likely modeled after Francesco himself.

Here, all the members of this alchemical laboratory are collaborating on a common purpose of transforming the elements, and also perhaps trying to learn the secrets of the spiritual world. I liked the picture immediately—it drew me in with its cheerful quality of industrious communal action, leading to a positive result for each person and for the group.

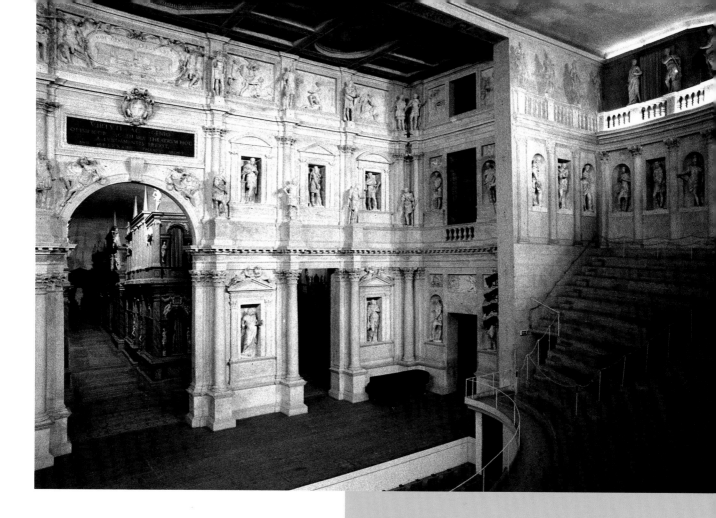

Teatro Olimpico (1579–1584)

Andrea Palladio
VICENZA

The Teatro Olimpico is Europe's oldest surviving theatre. It was begun by Andrea Palladio in 1579 and finished by his student, Vincenzo Scamozzi, in 1584. The first performance held here was Sophocles's *Oedipus Rex* on March 3, 1585. The theatre is still in use today.

The theatre has a wonderful feeling of aliveness, animated by all the carved figures. Each is separate from the others, yet connected in the pattern of the overall design. You can feel the spirit of the many productions that have taken place here, from the sixteenth century on up to the present. The figures evoke for me the spirit of any theatrical production, where each actor plays his/her part yet is in constant communication with the other actors and with the audience.

Interaction occurs not only between things which, to the senses, are near each other, but also between things which are far apart Things are united by a universal spirit which is present as a whole in the whole world and in each of its parts.

Oh friends, live freely and uninhibitedly without confining yourselves. Live with joy, for Heaven's joy created you with its motion and expansion. When you live with joy, heaven will preserve you. Live joyfully day by day in the present moment. For worry about the present steals it from you, and steals the future too. Worry about the future turns it into the past. Therefore I implore you, live joyfully.

Marsilio Ficino

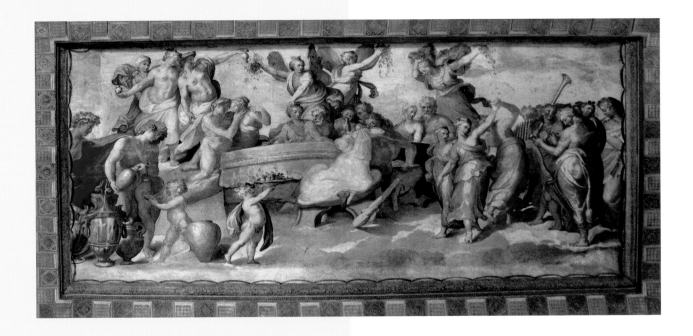

Synod of the Gods
(BEGUN IN 1565)

Ceiling fresco from the Hall of the Fountain
Girolamo Muziano and Associates
Villa D'Este
TIVOLI

When I saw this painting, I imagined Joyful Gods. Everyone seems to be having such a good time and to fit perfectly with Ficino's way of expressing, "Be here now." The Romans modeled their god Bacchus, who represented drunkenness, on Dionysus, the Greek god of wine, fertility, rebirth, and transcendence. Dionysus is the life force within us, calling us to experience joy as an unstoppable part of our existence and one that is necessary for our emotional well-being.

This fresco was inspired by a similar fresco done by Raffaello in the Villa Farnesina in Rome. Among those attending the banquet are all the gods of Olympus: Jupiter, lord of the heavens and the gods, is sitting in the center, Bacchus, god of fertility and wine, is mixing wine in the foreground, Apollo, god of the sun, truth, healing, and music, with his lyre is on the right. At the center, Hercules, the hero, who symbolizes physical strength and courage, turns to look over his shoulder at the viewer.

Certosa of Pavia (BEGUN IN 1396)

The Certosa, or Charter House, of Pavia, is a monastery complex near Milan. It was commissioned by Gian Galeazzo Visconti in 1396. The church was intended to serve as a mausoleum for the Visconti family. Work on the complex continued during the fifteenth and sixteenth centuries. The monastery originally housed the cloistered monastic order of Carthusians. Currently, Cistercian monks live and work here.

To reach the Certosa, one walks from the main road to the end of a long, w tree-lined street, where a gate opens onto a large courtyard and the elabora ornate facade of the monastery complex. Upon entering the capacious chur the sight of the light emanating from the small window, although a comm occurrence, evoked in me a feeling of mystery and wonder.

46

Marsilio Ficino

Visible light depends on invisible light just as the pale halo in the clouds depends on the light of the moon.

Every production of whatever kind is an alteration, while the substance always remains the same, since there is only one substance, as there is one divine, immortal being. Pythagoras, who did not fear death, but saw it as a transformation, reached this conclusion.

Giordano Bruno

Here Bruno speaks about his idea that everything has something of the whole within itself, and that everything interpenetrates everything else; so nothing is ever lost, only changes form. He lived his own philosophy. When he was sentenced to death by fire by the Roman Inquisition, Bruno is reported to have told them they had greater fear in pronouncing the sentence, than he had in receiving it.

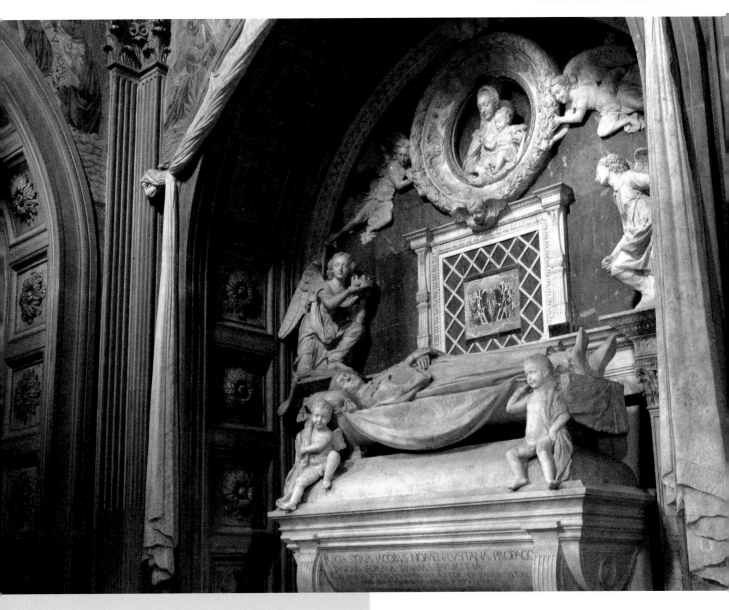

Tomb of the Cardinal of Portugal (1461–1466)

Antonio Rossellino
Basilica of San Miniato
FLORENCE

49

Man should devote all his energies to living in peace, in order not to add new miseries of his own making to the existing miseries of life. He shouldn't take offense at every nothing, every trifling incident, rather, he should be prepared to put up with a few little inconveniences, overlooking others' imprudence . . . trying his utmost to avoid conflict and scenes, and to live as harmoniously and as peaceably as possible. For whoever lives in peace is living in God, in a certain sense, since in paradise there is nothing but peace and charity; and God himself is peace and charity and paradise itself.

Moderata Fonte

I remember the day that I took this photograph. So often in churches, there is a 'no photographs' sign, or if not, someone who sternly tells you to put away your camera. But in this church, a kindly friar showed me around, and even offered to turn on a light so that I could get a better view. The church was his home in a sense and he seemed happy and proud to share it with me. His kindness was very moving.

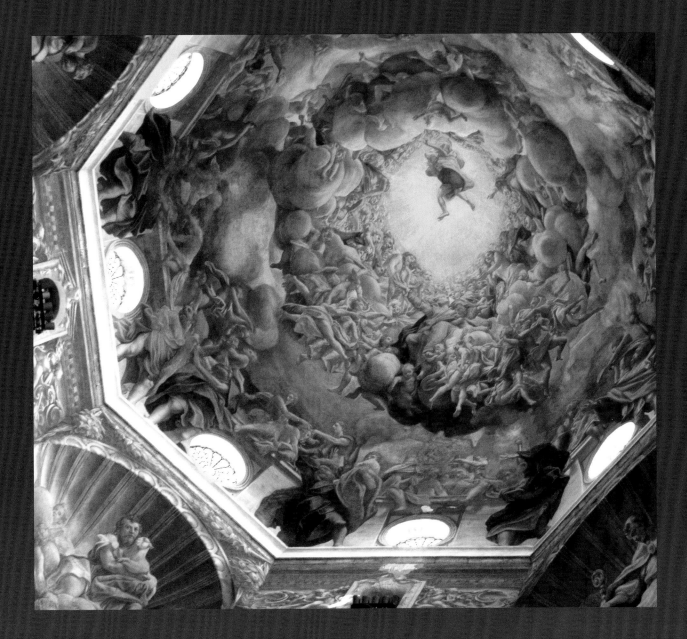

The Assumption of the Virgin (1530)

Antonio da Correggio
Parma Cathedral
PARMA

This fresco decorates the dome of the Cathedral. Here, the Virgin is carried up to heaven surrounded by angels.

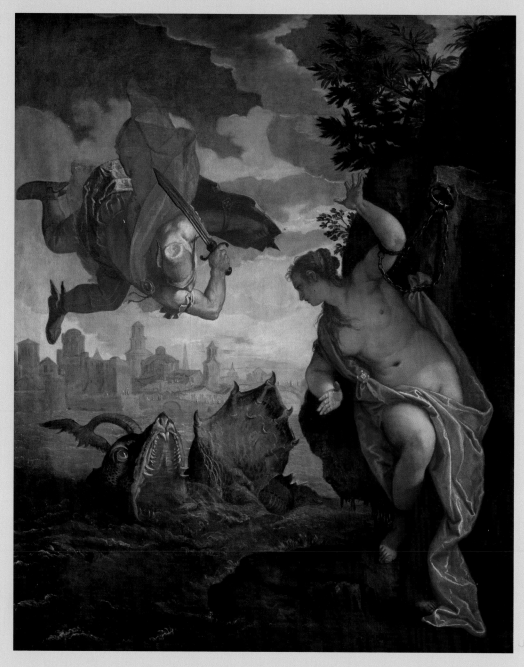

Perseus and Andromeda
(CA. 1580)

Paolo Veronese
Musée des Beaux-Arts
RENNES

In Greek mythology, Perseus is an archetypal heroic figure. Here he saves Andromeda, a princess who has been chained to a cliff and is about to be sacrificed to a sea monster. Perseus and Andromeda later marry.

2

Art

Inspired by Neoplatonism, Italian Renaissance fine artists and architects saw our transitory world as an imperfect reflection of an eternal world of perfect and changeless beauty. Through the excellence of their art, they could approach that world; through the appreciation of art, viewers could also experience its divine essence. Art could be a springboard towards the contemplation of the source of all earthly beauty. "Beauty is a true image of the Godhead," said the philosopher Francesco Cattani da Diacceto.

Princes had always been able to lavishly embellish their palaces, but with the growth of the merchant class and the urbanization of cities, many more people could afford to beautify their homes. The status of artists rose during the Renaissance, as did their numbers. In the major centers of Florence, Milan, Rome, and Venice, the creation of art and its patronage became a civic virtue.

Artists had more freedom than ever before to follow their *daemons,* their artistic visions, wherever they might lead. Their unconventional lives became acceptable and they were given a special place in society, because they were thought to be imbued with a spark of sacredness. Just as Orpheus had gone down to the Underworld to try to rescue Eurydice, the artist had to contact unseen forces to bring forth great works of fine art, poetry, and music. The wisdom of the Underworld cannot be discovered through logic, but through the imagination and the

arts. Ficino spoke of the 'divine frenzy,' the ecstatic state of inspiration from the godly source that an artist, poet, or musician experienced, and which impelled him to create.

Building and adorning God's buildings had always been a function of the artist, and during the Renaissance art with a religious theme continued to flourish. But, without giving up their Christian roots, artists now began to fill their works with mythological symbol and metaphor—with characters from the pagan world and also with symbolism from the Hermetic and Jewish mystical traditions. Some of these symbols were intended for a select, educated group, and some were more commonly known.

In speaking about the symbolic meaning of the planets, each ruled by a god from Greek or Roman mythology, Ficino wrote:

> *These celestial bodies are not to be sought by us outside in some other place; for the heavens in their entirety are within us, in whom the light of life and the origin of heaven dwell. For what else does the moon in us signify other than that continuous movement of our mind and body? Next Mars signifies swiftness, and Saturn tardiness; the Sun signifies God; Jupiter, law; Mercury, reason; Venus, human nature.*

Ficino encouraged going deeply into these allegories, seeing through the eyes of the soul, and reflecting upon the underworld of our own psyches. He saw these symbols as the microcosmic energies of the outer cosmos.

The roots of archetypal psychology can be found in the revitalization of the Greek and Roman figures by Italian Renaissance artists. It was Carl Jung who, in the early part of the twentieth century, spoke of archetypes, advancing the idea that these symbolic images and energies, which the ancients called gods and goddesses, are part of the collective human unconscious. Elemental forces which can come to life in each of us and ask for our attention and understanding, they urge us towards greater wholeness, towards self-realization.

Scala dei Giganti (1554–1556)

Jacopo Sansovino
VENICE

These statues of the gods Mars and Neptune symbolize Venice's dominion over land and sea. They flank the Scala dei Giganti, or Giants' Staircase, located at the courtyard entrance of the Palazzo Ducale, the Doge's Palace. Here, each new Doge would be crowned with his special hat called the *corno ducale* or doge's horn, and would give his speech promising to uphold the constitution of the Republic of Venice.

Jupiter

Bartolomeo Passarotti
Musée du Louvre
PARIS

Jupiter is lord of the heavens and the other gods. Here he is shown with lightening bolts and the eagle, symbols of his power. He represents prosperity, spiritual outlook, and wisdom, and brings the energy of expansion. Ficino recommended using images, colors, and minerals attributed to Jupiter in order to attract beneficial influences.

Painting possesses a truly divine power . . . [and] has contributed greatly to the piety which binds us to the gods, and to filling our minds with sound religious beliefs The ancient writer Trismegistus believes that sculpture and painting originated together with religion. He addresses Asclepius with these words: "Man, mindful of his nature and origin, represented the gods in his own likeness."

Leon Battista Alberti

The relationship or art to nature is the same as that of nature to God. Works of art remain uncorrupted as long as they are preserved by the power of nature: for instance, how long a statue lasts depends on the natural solidity of the stone or bronze. In the same way, natural objects last as long as they are preserved by God's divine influence.

Marsilio Ficino

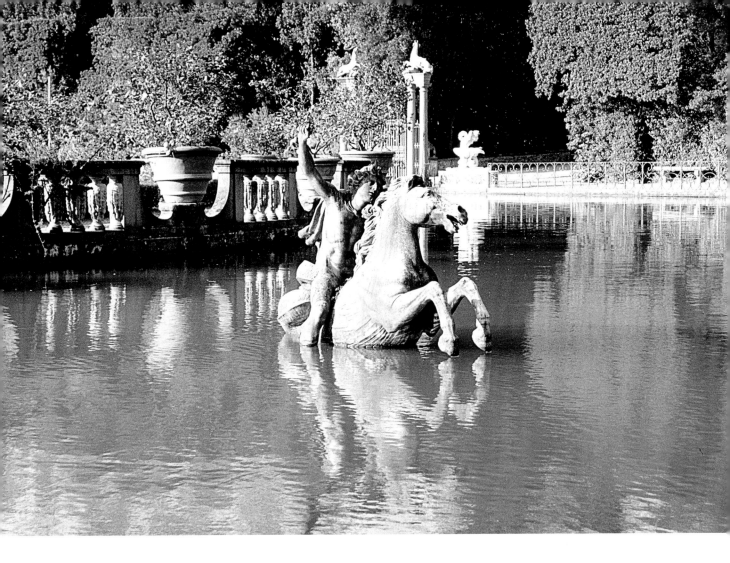

In Neoplatonic philosophy, the microcosm of the physical world was said to be a reflection of God's perfect universe based on mathematical principles, and Renaissance artists wanted to harmonize art with nature in their garden design. They had a penchant for evoking the spirit of a past 'golden age,' and writings on Arcadia and other mythic Greek gardens of bliss and perfection served as an inspiration. Arcadia was an artistic product, not a garden like any on earth, but a place of ideal beauty, where mythological creatures and human beings coexisted in a state of purity.

Perseus from the Oceanus Fountain

Giambologna
Boboli Gardens
FLORENCE

Perseus, son of Jupiter (the Greek god Zeus), lord of the gods, was a famous Greek hero who killed Medusa and saved Andromeda. Here he emerges from the water riding the winged horse Pegasus.

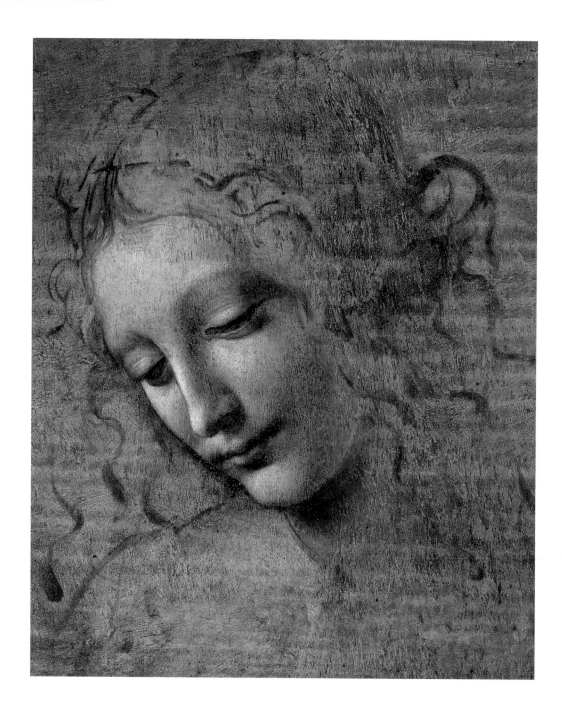

Where the spirit does not work with the hand there is no art.

Leonardo da Vinci

Head of a Maiden (CA. 1508)

Leonardo da Vinci
National Gallery
PARMA

Michelangelo

The more the marble wastes, the more the statue grows.

Although Michelangelo wanted to portray the divine beauty of the human body, he also showed the struggle of the soul, caught in the body. He is making visual the Neoplatonist idea of the soul's desire to free itself from the physical world and attain a vision of the Infinite, the One, or God.

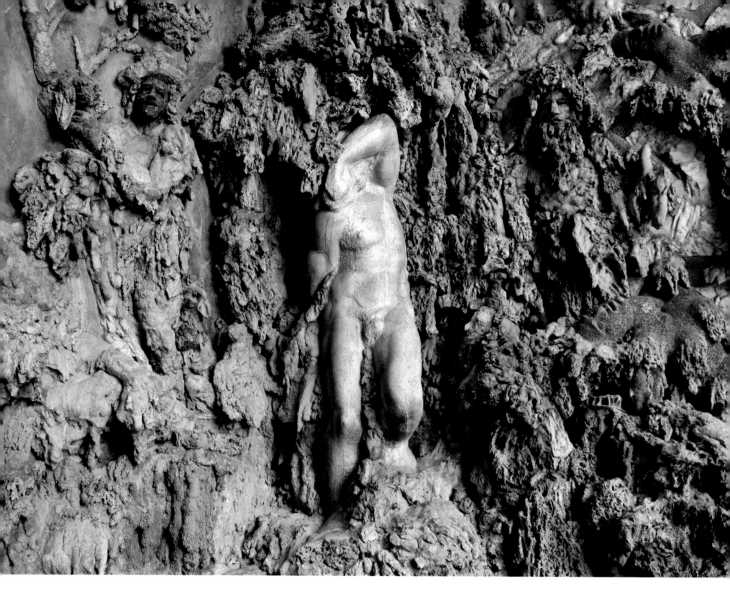

One of Four Prisoners

Michelangelo
Grotta Grande, designed by Buontalenti
Boboli Gardens
FLORENCE

The Grotto contains casts of the original, unfinished, statues by Michelangelo, which are now housed in the Accademia Gallery in Florence. They were intended for the tomb of Pope Julius II in Rome.

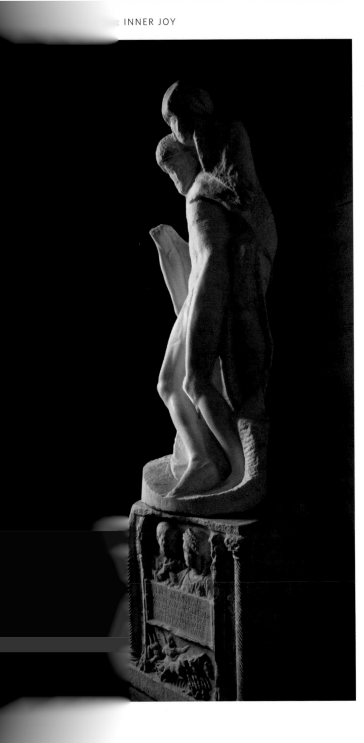

Rondanini Pietà (BEGUN IN 1555)

Michelangelo
Castello Sforzesco (Sforza Castle)
MILAN

The artist worked on this sculpture during the last nine years of his life. It remained unfinished at the time of his death in 1564.

The first, well-known, Pietà by Michelangelo, prominently placed in St. Peter's Basilica, is pristinely exquisite. However the second, created so many years later and left unfinished, is more compelling for me. I can see the suffering and courage of this Mary as she bears both her grief and the body of Jesus.

The true work of art is but a shadow of the divine perfection.

Michelangelo

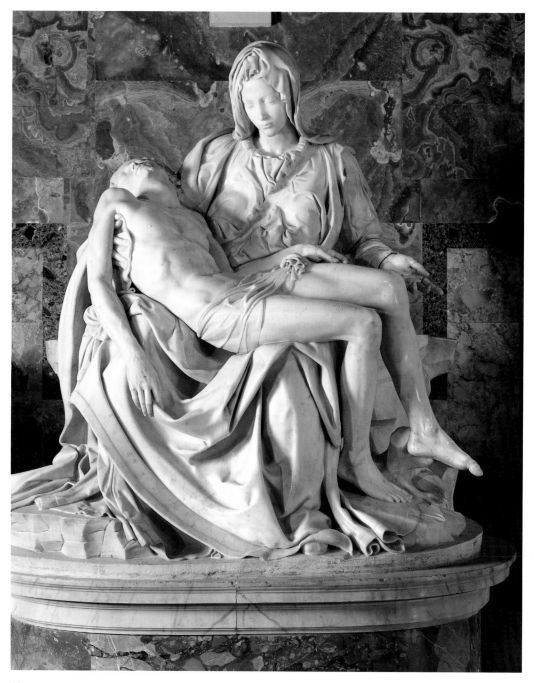

The Pietà (1499)

Michelangelo
St. Peter's Basilica
ROME

Michelangelo was only 24 when he created this sculpture of the slain Jesus on Mary's lap.

Moses (1513–1515)

Michelangelo
Church of San Pietro in Vincoli
ROME

This statue is part of a larger work, originally commissioned by Pope Julius II to serve as his tomb and intended to be in St. Peter's Basilica. Instead, it was placed in San Pietro in Vincoli (St. Peter in Chains) where Julius had been Cardinal.

In their book, *The Sistine Secrets,* Professor Benjamin Blech and Roy Doliner speak of Michelangelo's love for Jewish philosophy and his use of Jewish symbolism in his art. In Michelangelo's plan for the tomb, Moses, the greatest of all the Jewish prophets, would have been the centerpiece.

What appear to be horns on Moses's head were made to reflect light from a hole in the ceiling that Michelangelo created, but which church authorities later closed up. In Exodus, it is written that Moses's face shone when he descended from Mt. Sinai after receiving the Ten Commandments. Michelangelo wanted his statue's face to shine with divine light. (JR Books, 2008, pp. 236-238).

For Michelangelo, the human body was a reflection of the Divine, but also the inner self of a human being. Here, the strength and energy of Moses, seen in his muscular arms, his twisted position, and the fierce expression on his face, seem to radiate from the statue.

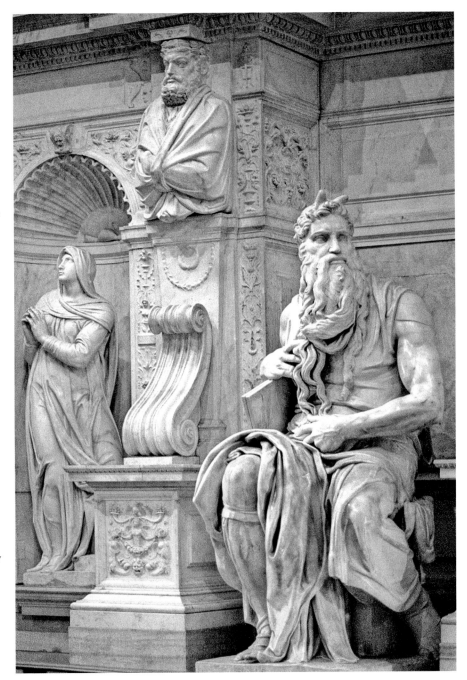

Giusti Gardens
VERONA

Created towards the end of the sixteenth century, the appearance of the Gardens today comes from the structure given to them in 1570 by Agostino Giusti, who was a knight of the Venetian Republic and a Squire of the Grand Duke of Tuscany. The Gardens have been visited for centuries by many, including Cosimo de' Medici, Goethe, and Mozart.

The things formed by nature serve as art's material, while a single, formless thing serves as nature's material.

Giordano Bruno

I'd roamed through Verona on a hot and dusty summer's day, eager to find the place I'd read was one of the most important Renaissance gardens in Europe. When I entered the gate and found myself among the green, green, geometrically laid out hedges, elegant, white marble statues, and fountains my fatigue dropped away, and I wandered about, enchanted. Renaissance literature contains many references to the *locus amoenus* or 'pleasant place'—where one could escape life's pain and struggles and rest in the contemplation of harmony and beauty. The Giusti Gardens certainly fit that description.

Beauty arouses our soul and seems to draw it towards itself; our soul naturally surmises that beauty opens the gates leading towards the limitless perfection of divine goodness.

Francesco Cattani da Diacceto

Madonna col Bambino DETAIL

Filippo Lippi
Palazzo Medici Riccardi
FLORENCE

This Madonna and child by Lippi is simply the most beautiful and loving image I have ever seen.

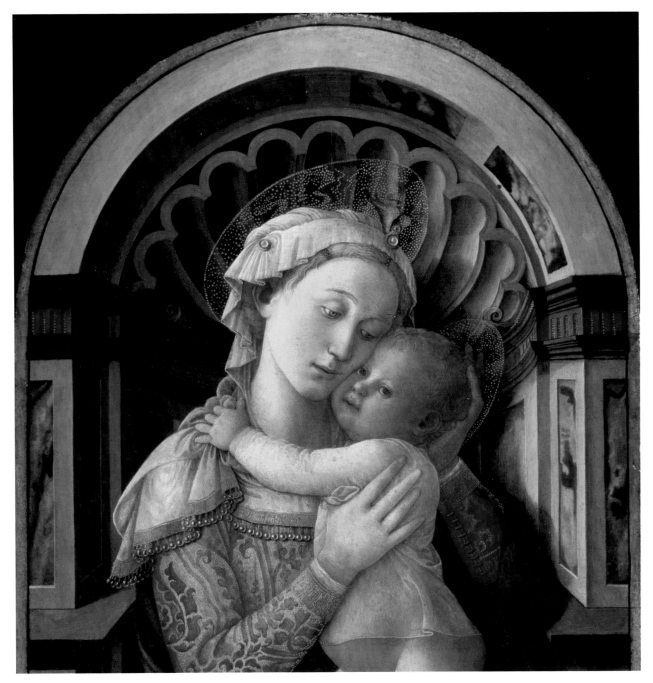

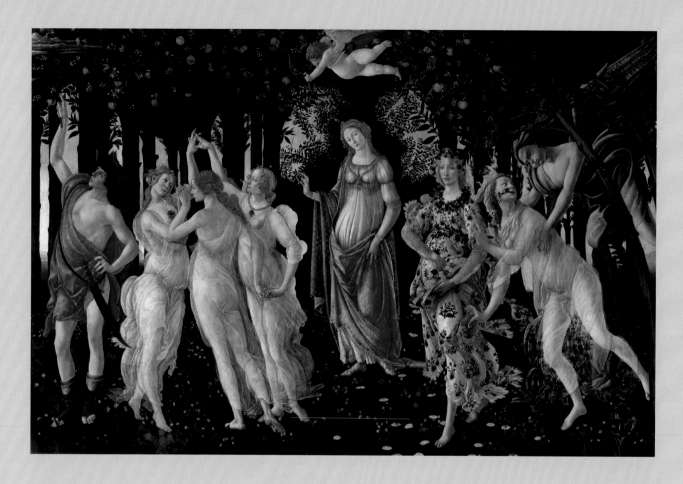

Primavera (1477)

Sandro Botticelli
Uffizi
FLORENCE

The philosophic meaning in this painting announcing the arrival of spring contains Neoplatonic themes inspired by Botticelli's involvement with members of the Platonic Academy, specifically Lorenzo de' Medici, Marsilio Ficino, Angelo Poliziano, and Pico della Mirandola. In the center is Venus, goddess of love, who here symbolizes moderation. Above, is her son Amor, or Cupid, shooting his love arrows. Zephyrus, the god of winds, is on the right, forcing his affections on Chloris, a nymph. She is being transformed into Flora, goddess of flowers who appears next to her. Here spring is associated with the awakening of sensual love and passion, but this love is undergoing a metamorphosis into a higher form of beauty. On the left are the three Graces, who symbolize Chastity, Beauty, and Love. Chastity, in the center, gazes at Mercury, who is using his staff to disperse the clouds and point to a higher reality. Following the idea of Ficino, human, sensual love is being shown as a pathway to divine love. But according to Edgar Wind, author of *Pagan Mysteries of the Renaissance,* the symmetrical placement of Zephyr on the right and Mercury on the left can also be understood as a representation of the ever-unfolding interplay between human passion and divine love. Therefore Zephyr's breath and Mercury's spirit are both aspects of the same creative impulse. (W.W. Norton and Co., 1968, p. 125).

3

Love

L ove is the linchpin that connects the material world with higher levels of existence. In Hermeticism and Neoplatonism, an individual can grow closer to his or her own true nature not only through study and contemplation, but also by appreciating and embracing the creations, or emanations, of God here on earth—nature, art, and other people. In Plato's *Symposium,* there is a description of a metaphorical ladder on which the seeker climbs, from the initial step of appreciating one earthly body or creation, to gaining the capacity to see the beauty in every body, then to perceiving the invisible beauty of the mind and soul. This ever-increasing awareness leads to the perception and understanding of the hidden beauty of the world, that which lies beyond the five senses.

In the introduction to Ficino's *Commentary on Plato's Symposium on Love,* translator Sears Jayne speaks of Ficino's concept of love as being the desire to return to one's source, with the quality of beauty as a cause of the attraction. In humans, earthly love is the desire to create other physical beings, whereas heavenly love is what makes us want to rise to higher levels of existence. Both are good, as both are part of the natural process of the cosmos (Spring Publications, 1985, p. 7).

When Eros, god of love, strikes us with his arrow, he awakens and compels us to abandon our usual rational way of thinking and follow our hearts. We receive an exalted vision of the one we love, and therefore we see his or her true nature. "Why do we think love is a magician?" said Ficino in his *Commentary on Plato's Symposium on Love*. "Because the whole power of magic consists in love. The work of magic is the attraction of one thing by another because of a certain affinity of nature."

In Ficino's concept of Platonic love, two people could attain the highest possible kind of friendship when their personal relationship mirrored their love for God, when they could see the divine spark in each other. Therefore, human love is a reminder of our true source, and when we love, we move to a more refined perception of reality. Ficino wrote: "He who properly uses love certainly praises the beauty of the body, but through that contemplates the higher beauty of the soul, the Mind, and God, and admires and loves that more strongly."

After Ficino completed his translation of Plato from the Greek into Latin, and with the advent of the printing press, a widespread diffusion of Platonic ideals occurred among intellectuals, artists, and writers. People also began to speak about sexual love in a new way, praising the kind of relationship that united body and soul. Ficino's *Commentary on Plato's Symposium on Love* became enormously popular in many of the courts of Europe.

The Renaissance theory of love distinguished between two kinds of sexual love. In the first kind, driven by lust, one person uses another to satisfy the body's appetite. This kind of commonplace love brings temporary pleasure but can't fulfill the soul's desire for union. In the second kind of love, called noble love, desire comes not only from the body, but from the soul's desire to merge with another soul. In this kind of union, sexual love can't quell the desire one person has for the other and in fact serves to increase it. In this way, noble love was said to be limitless and eternal, having the power to take two people beyond their personal limitations towards something greater than themselves. Therefore carnal love was said to be of the same essence as divine love, and, when used for the highest good of both partners, to contain the seeds of immortality.

The subject of the equality of men and women was a natural counterpart to the philosophy of love. The firmly entrenched opinion that men were by nature superior, that women were by nature weak and intellectually inferior, slowly began to lose power. Some even said that men and women possessed the same virtues. Both men and women wrote books in the form of dialogues, revealing divergent attitudes.

With the classical revival, writers used mythological figures and their exploits as themes in poetry and literature. Ideals of classical composition fascinated artists, who admired sculptures of the gods and goddesses from the Greco-Roman world. The perfectly proportioned bodies of these ancient statues affirmed Plato's idea that the physical world is a representation of a perfect and changeless divine world. Thousands of nudes were painted and sculpted during the Renaissance. In the hands of the great artists, the fragile, primal, naked human form gained a divine perfection, one that seemed to transcend mortality.

Nude images decorated both public and private spaces. Italian aristocrats had their villas adorned with frescoes and statues. Michelangelo created his giant *David* to stand in the center of Florence; his *Adam* to grace the ceiling of the Sistine Chapel. The physical body could now be accepted as part of the manifestation of God, the One Supreme Being.

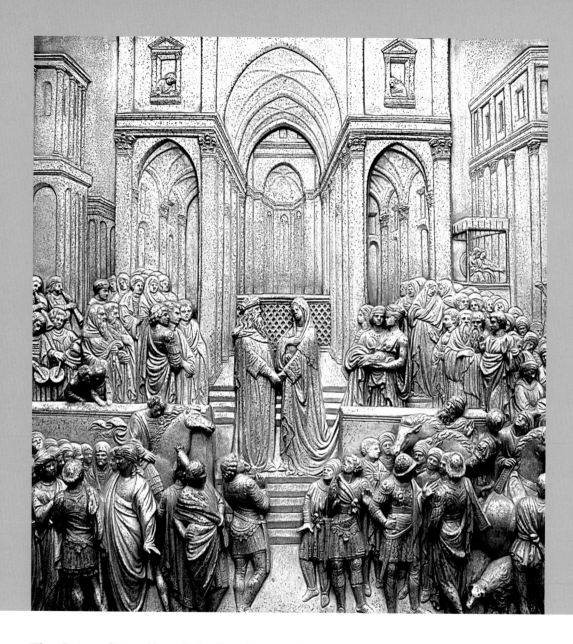

The Gates of Paradise of the Baptistery of St. John (1452)
Solomon and the Queen of Sheba

Lorenzo Ghiberti
FLORENCE

Notice how Solomon, when he wanted to write mystically of very exalted and divine things . . . imagines an ardent and amorous dialogue between a lover and his lady, since he thought it was impossible to find in this world any more suitable and exact analogy for divine things than a man's love for a woman.

Baldessare Castiglione

The Baptistery has three sets of renowned gilded bronze doors covered with relief sculptures. Andrea Pisano made the south doors in 1336, and Ghiberti made the north in 1427, and the east in 1452. The east doors are called the *Gates of Paradise,* a name said to have been given them by Michelangelo.

Cupid is shown naked, because when you are in love it's impossible to talk yourself out of it rationally . . . as a child, because you lose your good sense . . . as winged, because of the speed with which love enters your soul and makes you pursue the object of your desire . . . as an archer, because love can wound you from a distance, aiming at your heart, without your knowledge. The arrow pierces deep and creates a wound that's difficult to see, difficult to care for, and difficult to heal.

Leone Ebreo

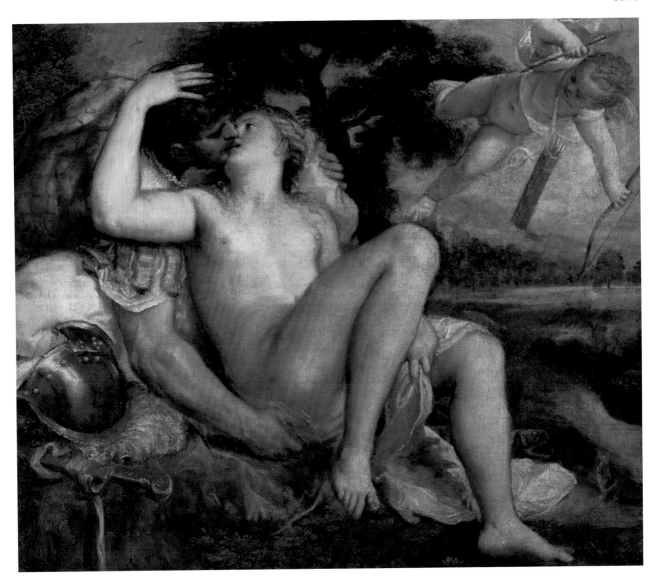

Mars, Venus, and Amor (1530)

Tiziano
Kunsthistorisches Museum
VIENNA

It seems that when we fall in love, whether the feeling is returned or not, it somehow makes us acutely aware of everything. Even when two people do share a reciprocal love, there is a painful aspect to it. We feel cracked open, no longer able to close ourselves off in our own protective shells. But although the arrow of Cupid wounds, it also creates an opening for the soul to apprehend the beauty of another, and makes it possible to perceive the Divine, that essence of aliveness, embodied in the physical world.

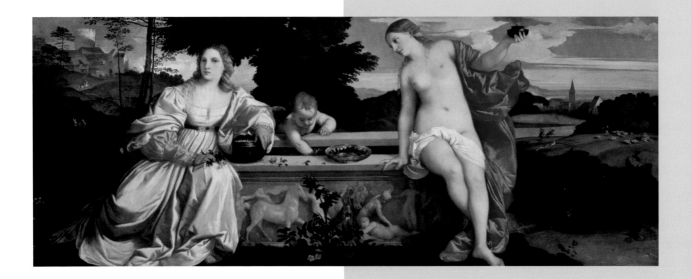

Amor Sacro e Amor Profano (CA. 1515)

Tiziano
Borghese Gallery
ROME

In this painting set in a beautiful landscape, two women meet at a tomb made into a fountain of love, presided over by Cupid. The tomb might be seen as a symbol of the material world, and the two women as two kinds of love, one earthly, one divine. Ficino spoke of two Venuses, and two different kinds of love. Although one might think that the woman in white represents sacred love and the nude one profane love, the opposite is probably the case. In the background behind the nude woman is a church, and in her hand is a burning jar of oil, representing eternity, while the clothed woman holds gold and gems. But she wears no jewels, is simply dressed, and only carries a few flowers. Perhaps both the women represent the idea of noble love, one physical and human, and one eternal and divine.

There are two ways to love: Let's call one vulgar or 'dishonest' and the other 'honest' or virtuous. Dishonest love exists among coarse, crude people whether they're from the upper class or low. [It's] born of a desire to get pleasure from the thing that is loved. As soon as they've gotten what they wanted they don't love anymore. Often . . . their love turns to hate. Honest love . . . is characteristic of noble people whether they're rich or poor . . . the principle aim of this kind of love is the transformation of oneself into the object of one's love, with the wish that the loved one be transformed as well . . . so that the two become one.

Tullia D'Aragona

So sweet and delicious do I become

when I am in bed with a man

who, I sense, loves and enjoys me,

that the pleasure I bring excels all delight,

so the knot of love, however tight

it seemed before, is tied tighter still.

Veronica Franco

Veronica Franco would have been an extraordinary woman in any age, and in fact gained fame again in our age through Margaret Rosenthal's 1993 study of her, *The Honest Courtesan: Citizen and Writer in Sixteenth-Century Venice,* and a film that was subsequently made, *Dangerous Beauty.* A poet and courtesan, Franco was an educated Venetian *cortegiana onesta,* an intellectual courtesan, and one of the most celebrated. Here she seems to be referring to the 'honest' love that Tullia D'Aragona, another celebrated courtesan, also wrote about.

According to the legend of Cupid and Psyche as written about in the second century A.D. by Apuleius in his novel, *The Metamorphoses,* or *The Golden Ass,* Cupid falls in love with Psyche, the most beautiful woman in the world, against the wishes of his mother, Venus, goddess of love. Cupid has Zephyr, god of the winds, bring Psyche to his palace. Cupid comes to Psyche only at night, and tests her love for him by making her promise not to look at him. But she can't resist, and after a drop of lamp oil falls on him while he is sleeping, he abandons her. Then Venus makes Psyche wander the earth to accomplish many difficult tasks. Finally, Cupid returns to Psyche, and Jupiter, Cupid's father, allows them to be married on Olympus, mountain home of the gods. Psyche later has a child, named Voluptas, meaning Pleasure or Joy. In this photo, Cupid, Psyche, and Voluptas are seen together in bed.

The myth has various and complex interpretations. In Neoplatonic terms, the story can be understood as describing the relationship of the human soul, Psyche, with divine love, Cupid. Psyche's desire to see Cupid results in her losing him. But after she has atoned for her curiosity, she regains Cupid and is granted immortality. Therefore love is higher than reason. By knowing the joys of human passion, one might guess at the greater joys of heaven.

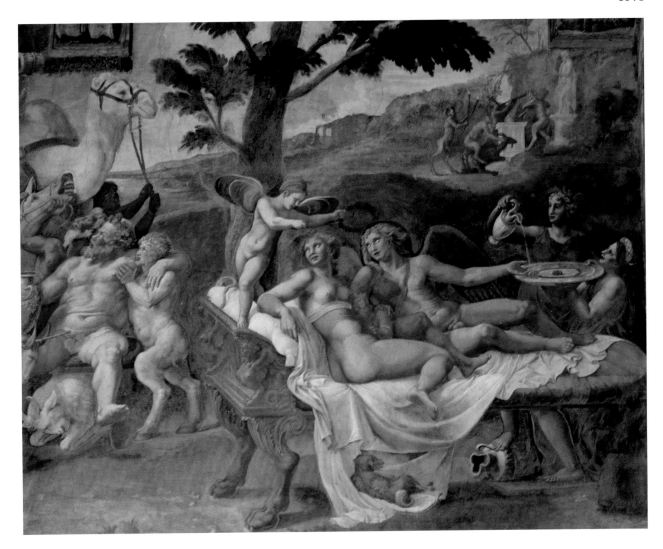

When I went to the Palazzo Te, I was dazzled by all the frescoes here. People walked quickly enough through the other rooms, giving me plenty of time and space to take a few photos. But in this room, everyone lingered. The paintings are remarkable in their unabashed celebration of physical love.

Chamber of Amor and Psyche, Palazzo Te (1526–1528)

Giulio Romano
MANTUA

The Gonzaga family ruled Mantua for centuries, and Federico II Gonzaga governed from 1519 until 1540. He commissioned Giulio Romano to create the Palazzo Te as a retreat where he could spend time with his mistress, Isabella Boschetta. The Palazzo was also used to receive important guests.

83

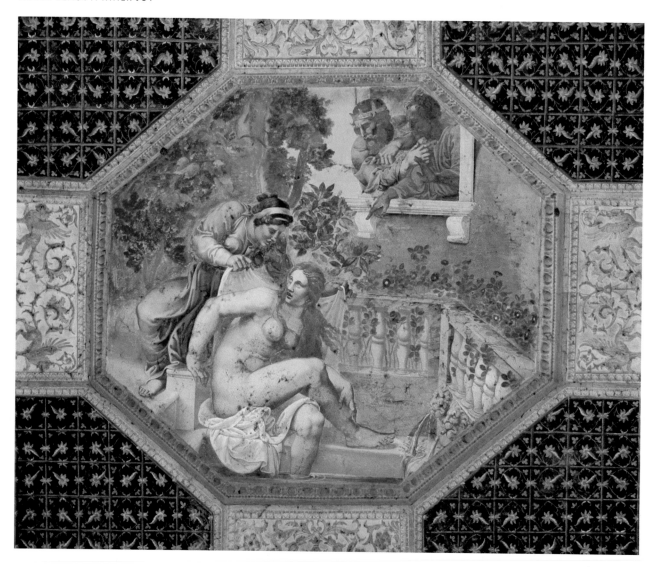

Fresco (1525–1535)
DETAIL

Palazzo Te
Giulio Romano
MANTUA

In her book, *The Worth of Women*, Moderata Fonte gathers a group of educated Venetian women—young, old, married, and single—to discuss the pros and cons of marriage. It is amazingly modern in its scope, and its subject matter is as relevant today as it was during the sixteenth century.

Moderata Fonte

When a man has amorous concourse with a woman, the result is the greatest shame for her and a certain amount of credit for him; so that the woman always tries to disguise it as much as possible, while the man cannot wait to tell the whole world about it, as though his glory and happiness depended on it. Surely this is a way of declaring the dignity and nobility of women and the corresponding indignity of men.

Ludovico Ariosto

If the same ardor, the same urge drives both sexes to love's gentle fulfillment, which to the mindless commoner seems so grave an excess, why is the woman to be punished or blamed for having done with one or several men the very thing a man does with as many women as he will, and receives not punishment but praise for it?

Ariosto's epic poem, *Orlando Furioso,* is a chivalric legend, a parody of medieval romances, and a monument to Italian Renaissance court society. It was enormously popular in its day. Ariosto's endorsement of sexual equality seems a good counterpart to the love affair between Venus and Mars.

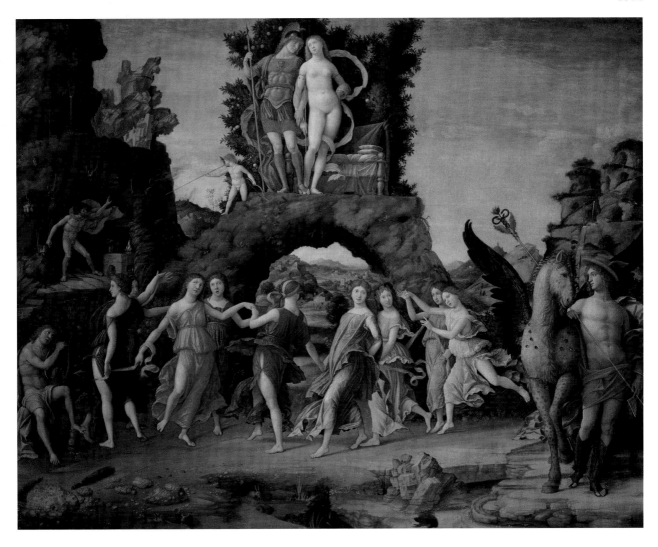

Parnassus, Mars and Venus (1497)

Andrea Mantegna
Louvre
PARIS

Parnassus is a mountain in Greece, sacred to the ancient gods and goddesses. Venus, goddess of love, although married to Vulcan, the god of fire and metalworking, who is often portrayed as a deformed and squalid man, falls in love with Mars, god of war, and has an affair with him. In Renaissance philosophy, Venus tempers the warlike tendencies of Mars, and their union produces harmony.

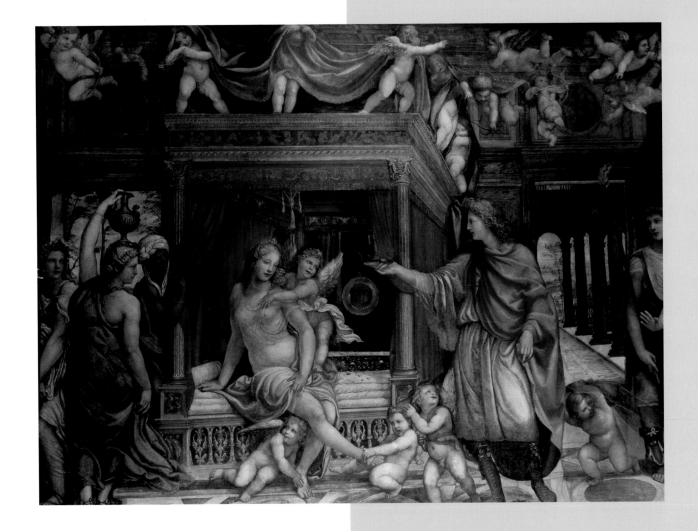

Wedding of Roxana and Alexander (CA. 1517) DETAIL
SALA DI SODOMA (ALSO KNOWN AS AGOSTINO'S BEDROOM)

Giovan Antonio Bazzi (called *Il Sodoma*)
Villa Farnesina
ROME

The villa, originally owned by banker Agostino Chigi, and once known as Villa Chigi
(it was acquired by the Farnese family in 1582), was created between 1506 and 1511;
but work continued on the interior until about 1519. The Sala di Sodoma served as the
bedroom for Chigi and his wife, Francesca Andreazza, whom he married in 1519.

This fresco of the famous conqueror
Alexander the Great and his bride,
Roxana, embodies for me the sentiment
of Diacceto's words. The noble beauty
and delicacy of the figures, the presence
of the angels hovering gently all around
the scene, the respectful onlookers,
all epitomize the sanctity of true and
enduring love.

It is . . . immensely important . . . to value a legitimate lover as highly as possible It is no less pleasing to the gods to see a lover honoured, extolled and revered by his beloved than if they themselves were praised in solemn worship. For the lover always dwells with his beloved, continuously directed by a divine madness. This is why the beloved must understand that not only in this life, but also in the next, countless favors will be heaped upon him.

Francesco Cattani da Diacceto

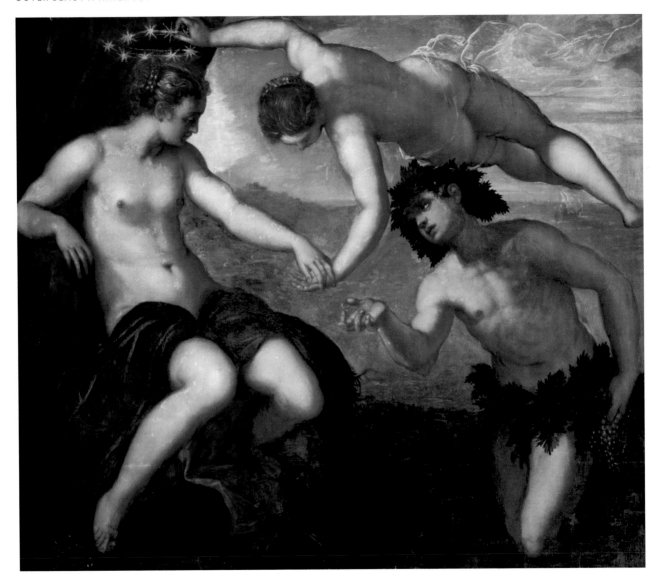

Ariadne meeting Bacchus and
Crowned by Venus (1576)

Tintoretto
Palazzo Ducale
VENICE

Pietro Bembo

Virtuous love is not merely desire of beauty . . . but desire of true beauty, which is not of that human and mortal kind which fades, but is immortal and divine.

According to myth, Dionysus, also known as the Roman god Bacchus, half-god, half-mortal, discovered Ariadne, daughter of King Minos of Crete, on the island of Naxos, where she had been abandoned by her husband, Theseus. Dionysus and Ariadne fell in love and enjoyed a perfect union. According to one version of the myth, a condition of their marriage was that Ariadne must never see the godly aspect of Dionysus. When she insists, he can refuse her nothing, and the sight of him causes her death. Dionysus places her crown with the stars. It is now known as the Corona Borealis.

Love, your beauty is not a mortal thing:

there is no face among us that can equal

the image in the heart,

 which you kindle and sustain

with another fire

 and stir with other wings.

Michelangelo

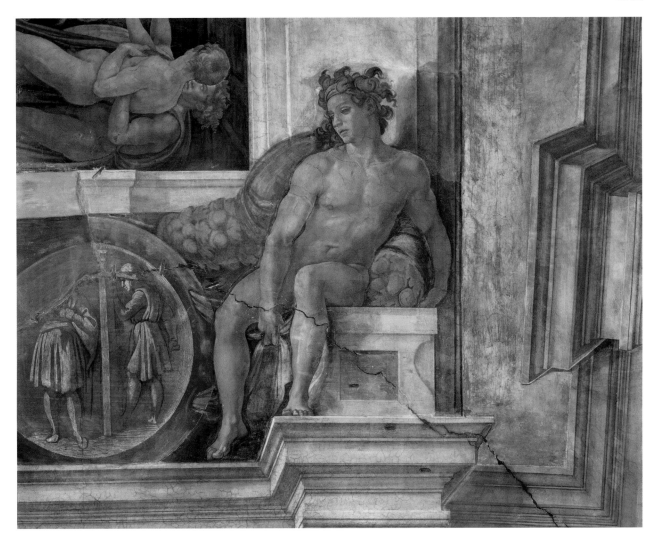

Ignudo (1508–1512)
DETAIL, SISTINE CEILING

Michelangelo
Vatican Palace
ROME

Michelangelo was taken into the household of Lorenzo de' Medici at an early age and grew up in the atmosphere of Neoplatonic ideals. Here, he is speaking of the concept of seeing divine beauty in the beauty of a human being. He believed that the true artist had a gift of perceiving this invisible beauty and putting it into visible form as a painting or sculpture. Michelangelo focused on human subjects and felt that the role of an artist was to represent an ideal beauty as a reflection of the beauty of the soul.

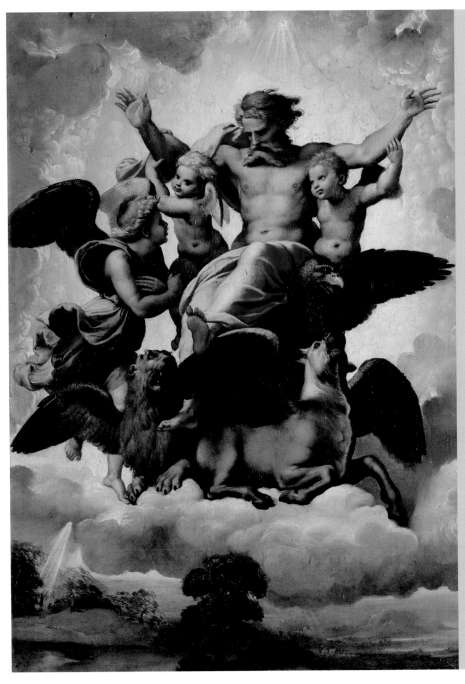

The vision of the prophet Ezekiel (1518)

Raffaello
Galleria Palatina, Palazzo Pitti
FLORENCE

This sweet and playful painting is filled with an innocent sense of joy. For me it exemplifies the saying that we have to become as little children to enter the kingdom of heaven. And it just seemed to go perfectly with Lorenzo's words.

We know Lorenzo for being the ruler of Florence, head of the Medici bank, and a leading statesmen, as well as a patron of great humanists such as Marsilio Ficino, Pico della Mirandola, and Angelo Poliziano, and artists such as Leonardo, Michelangelo, and Botticelli, to name just a few. But he also had literary gifts, and was a major man of letters of fifteenth-century Florence. He wrote in the Tuscan dialect, thereby aligning himself with Dante, Petrarch, and Boccaccio. Through his patronage, his eloquence and intellect, and his creation of the Laurentian library, he embodied the prototype of a wise and enlightened ruler.

However long the soul intently stares

we still will only see as through a fog

the chasms of divine infinity.

We love Him with a true and perfect love:

to know God is to drag Him down to earth;

to love Him is to soar up to His height.

Lorenzo de' Medici

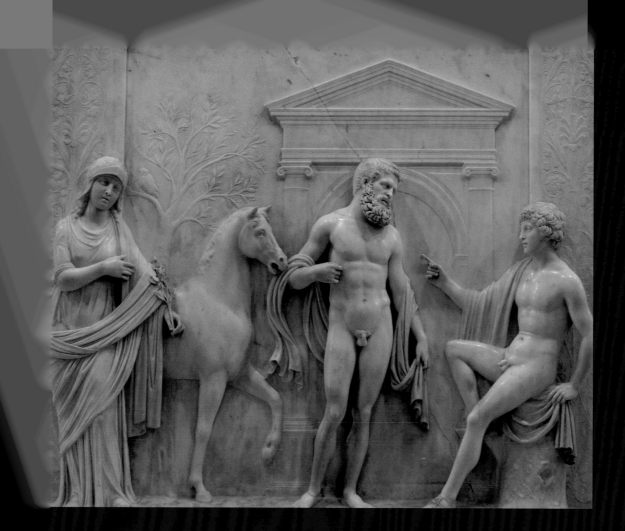

The contest between Minerva and Neptune for the possession of Attica (1508)

Antonio Lombardo
The Estense Castle
FERRARA

Minerva, called Athena in Greek mythology, won a challenge with Neptune, god of the sea. It was determined it was she who could give the greatest gift to humankind. Her gift is the olive tree, representing wisdom.

is the patroness of the city of Athens (Attica), the birthplace of Western philosophy

4

Self-Determination

T he great plagues, which spread along trade routes from Asia throughout Western Europe during the fourteenth century, instigated a revolutionary change in thinking. Millions died and virtually everyone experienced the loss of loved ones. Church dogma and abstract ways of reasoning about life no longer sufficed. The medieval worldview—that all of creation had its determined and unmovable place in existence—came to be challenged, and with the dawning of the Renaissance, people began in earnest to observe the world within and around them, and come to their own conclusions. Renaissance Humanism was inspired by a personal quest for truth and fostered a belief in the ability of humans to elevate themselves through knowledge. The academic groups that had formed around distinguished teachers during the Middle Ages now grew to become the first universities. As in the past, scholarship maintained a religious emphasis; but as time went on, preoccupation with religious matters ceded to the fascination of recent discoveries and explorations.

Batholomew Diaz rounded the Cape of Good Hope at Africa's southern tip in 1488; Vasco da Gama reached India in 1498; and Christopher Columbus set off in 1492 on the first of a series of voyages, searching for a way to reach Asia by sailing West. When he touched land in the Caribbean, he thought he had reached Asia, never realizing he had arrived in another part of the world.

Studies in anatomy became more widely accepted and the use of corrective lenses for vision led to the discovery of the telescope. There was an expansion of knowledge in both the inner and outer worlds of humankind.

But philosophy, science, and religion remained intertwined, and new ways of viewing the cosmos existed alongside traditional ones. Leonardo da Vinci studied the structure of the Earth and described it in terms of correspondences, comparing it to the human body. For Leonardo, everything in nature was alive:

> *We can say that the earth has a vegetative soul, and that its flesh is the land, its bones are the structure of the rocks . . . its blood is the pools of water . . . its breathing and its pulses are the ebb and flow of the sea.*

Although the universe was still seen by many as a creature of which all were a part, Renaissance Neoplatonists also believed that the fundamental truths of the universe were based on mathematical principles. The philosophical tradition begun by Pythagoras and his followers in the sixth century B.C. held that everything in the universe was related to numbers, and that they were the ultimate reality. Plato, too, felt that mathematics and abstract thinking could serve as the basis for arriving at philosophical truths. In Jewish mysticism, each letter of the Hebrew alphabet has a numerical value, and words can contain meanings that connect the material and spiritual worlds. During the fifteenth century, Nicholas of Cusa (Nicolaus Cusanus), a German cardinal, philosopher, mathematician, and astronomer, also said that mathematics was a path to discovering divine ideas and paved the way for the discoveries of Nicholas Copernicus. A Polish astronomer (who, along with other exceptional men of his age, held many titles), Copernicus formulated the scientific theory of heliocentrism and demonstrated that the earth moved round the sun. As the Renaissance drew to a close, the belief that the physical world was mathematical in nature, along with the acceptance of empirical study, led to Galileo's insistence that nature is written in the laws of mathematics.

The greater knowledge and innovation that came through science and experimentation, combined with the resurgence in Platonic and ancient esoteric studies, led writers and philosophers to assert that, by using their own efforts, humans had the ability to raise themselves to higher levels of consciousness. Although Italian humanists and Neoplatonists were Christian, their interest in ancient philosophies opened the door to the acceptance of other belief systems. Many wanted to learn about differing schools of thought, attempting to reconcile what they learned with their own Christian worldview. Each person is responsible for the direction of one's own life, they claimed, and must work out one's own truth. Among the elite, the trend was towards greater autonomy of the self and spiritual evolution through observation and discovery.

Ficino believed that the human soul, situated midway between the physical world and the divine world, contained the essence of all things. According to the ancient Hermetic creation myth, in the distant past humans had experienced a fall from a heavenly state of unity and had become bound up with the material world. But Ficino taught that through purification and contemplation, one could break through these restrictions and begin the process of rising to higher planes.

Giovanni Pico della Mirandola was perhaps the greatest defender of the syncretic method, taking ideas from various philosophies and combining them in his own writing. He took a particular interest in the Hebrew language and Jewish mystical texts, and he studied under the guidance of some of the greatest Jewish scholars living in Italy at the time.

In 1486, at the age of 23, Pico invited scholars from all over Europe to come to Rome for a public disputation of 900 theses he had drawn from diverse Latin, Greek, Hebrew, and Arabic writers. But a papal commission denounced his work, and Pope Innocent VIII prohibited the event from taking place. Pico's great work, *Oration on the Dignity of Man,* has been called the 'Manifesto of the Renaissance.' It stresses the ability of humans to transform themselves through the use of free will and thereby shape their destinies.

A man will never become a philosopher by worrying forever about the writings of other men, without ever raising his own eyes to nature's works in an attempt to recognize there the truths already known and to investigate some of the infinite number that remain to be discovered.

Galileo Galilei

Campanile and Palazzo Ducale

VENICE

The campanile (bell tower) was completed in the twelfth century, but its appearance today dates from the sixteenth century, when it was restored after an earthquake. It collapsed again in 1902 and reopened in 1912. It was here where Galileo demonstrated his telescope to the ruler of Venice, Doge Leonardo Donà, in 1609.

Colossus of the Appenine (1581)

Giambologna
Villa Demidoff
PRATOLINO

This sixteenth-century gigantic statue stands in a park adjoining the Villa Demidoff near Florence. It is the most impressive of several remaining sixteenth-century creations on the estate, which was once owned by Francesco I de' Medici, and filled with elaborate waterworks and statuary. The Colossus has his hand on the head of a sea monster, which sends out water into the basin below. There is a dragon carved on the back of the statue. In Jungian psychology, the dragon is an archetype representing the unconscious mind that has to be slain by the Hero.

One cannot have greater lordship or lesser lordship than over oneself.

Leonardo da Vinci

He who harms others does not make himself secure.

Leonardo da Vinci

Rape of the Sabine Women (1579-1583)
STATUE IN FOREGROUND

Giambologna
Loggia dei Lanzi
FLORENCE

According to legend, the first generation of Roman men forcibly took women from the neighboring Sabines for their wives.

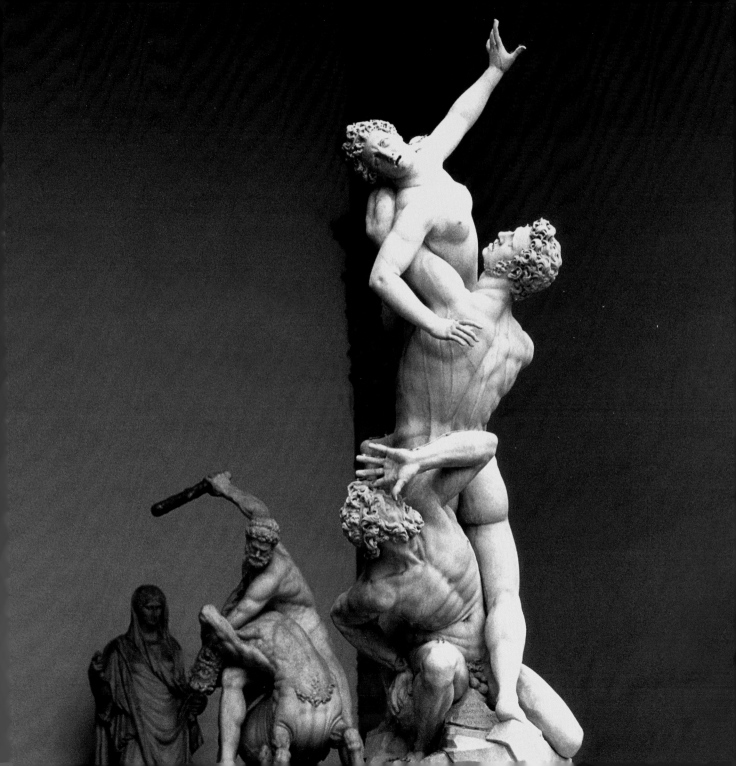

Piazza del Campidoglio (1538)

Michelangelo
Replica of Roman statue of Marcus Aurelius
ROME

One of the most important Stoic philosophers,
Marcus Aurelius was Emperor of Rome from
A.D. 161 to 180. The original statue is now housed
in the Palazzo dei Conservatori.

This quote is embodied for me in the statue of Marcus Aurelius,
one of the greatest Stoic philosophers. He wrote twelve books
called *Meditations,* meant for his own self-improvement, and he
advocated not indulging in emotions in order to keep ourselves
from being overpowered by our reactions to others—which robs
us of our innate freedom. Plato speaks of a charioteer driving
two horses, one representing intellect or reason, the other,
passion. Only by keeping the two in balance can we move
toward enlightenment.

All emotions are related to the soul. But they are related to it in the same way that good or bad health is related to the body Therefore, whatever the emotions do . . . is our responsibility. In a well-adjusted body good health is produced by the disposition we call equilibrium, and it is destroyed when the balance is tipped in the direction of either excess or deficiency. The same things undeniably happen in relation to the emotions. When they are unrestrained and violent, they make a man miserable, but when moderate and orderly, they make him happy. The soul, as Plato wrote with divine inspiration, is like a charioteer or a horseman.

Angelo Poliziano

Portrait of a girl with the *Petrarchino*, a small edition of poems by Petrarch (CA. 1514)

Andrea del Sarto
Uffizi
FLORENCE

An early feminist, Terracina published eight volumes of poetry and was the most prolific woman poet of the sixteenth century. All her life, she acted on her belief In women's need to succeed artistically. To that end, she passionately encouraged and chided women to gain equal opportunity with men.

If only women would give up their needles,

Their thread and cloth, and would take up their studies,

I think, then, they could wound you, o male writers,

More than the Carthaginians hurt the Romans.

But since so few women have done this, so little

True fame has garlanded our heads with laurel.

Not many women take the pains I speak of,

To labor night and day and never rest.

And therefore do not cease, gifted women,

To launch your ships of talent on the ocean!

Forget your needles, make yourselves more eager

To labor frequently with pen and paper.

Thus you can win as glorious a fame

As men of whom I bitterly complain.

Laura Bacio Terracina

Pope Pius II (Aeneas Piccolomini) Canonizes
Catherine of Siena (1502–1508) DETAIL

Bernardo Pinturicchio
Piccolomini Library, Sienna Cathedral
SIENA

Many may be brought to profess, but no one can be forced to believe. There is nothing more vital than independence of judgment; as I claim it for myself I would not deny it to others. I grant you (for it is possible) that every man's purpose is honorable and sacred; I would not constitute myself the judge of the deep and hidden mysteries of the human conscience.

Francesco Petrarca

Born in 1347 in Siena, St. Catherine was a woman of independent judgment who spoke her mind to commoners and Popes alike. Here, Pinturicchio uses the opportunity of her canonization, which took place only 81 years after her death, to include these wonderful portraits of Raffaello and himself (bottom, left).

The Great German Scola (1528–1529)

Ashkenazi synagogue
VENICE

The synagogue still contains the original walls covered with *marmorino,* a kind of antique plaster made of lime paste and marble dust. Also remaining from the sixteenth century is an inscription from the Ten Commandments.

Although Jews had lived and worked in Venice for centuries with various restrictions, in 1516 Venice instituted the ghetto. Each ethnic group that settled in Venice built their own synagogues, called Scole.

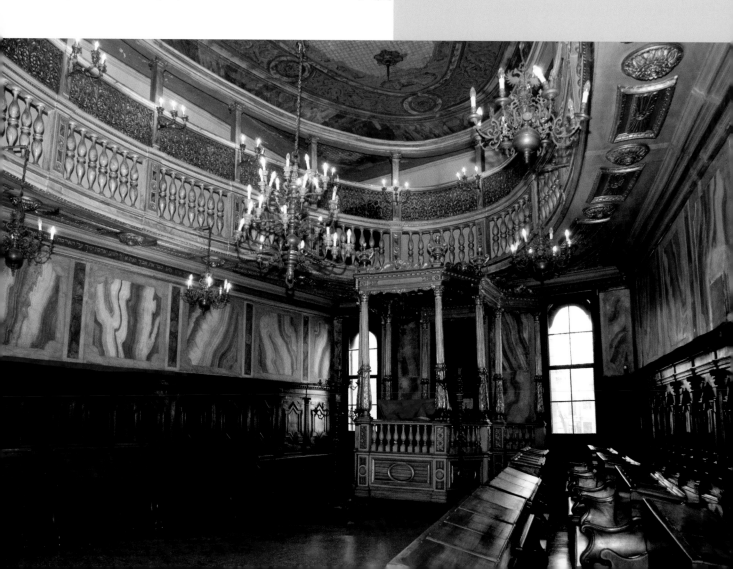

Any school which attacks the philosophical doctrines of another established school, and mocks its valid principles, strengthens rather than weakens those principles By comparing many schools and discussing many philosophical systems, that brilliant radiance of truth, which Plato writes about in his letters, may illuminate our minds like the sun rising in the heavens.

Pico della Mirandola

This statement exemplifies the spirit of the Renaissance philosophers who opened their minds to receive the truth in whatever form or from whatever tradition it presented itself. Pico was a great student of Jewish wisdom and is said to have had the largest library of Kabbalistic texts ever gathered in one place.

You may, as the free and proud shaper of your own being, fashion yourself in the form you may prefer. It will be in your power to descend to the lower, brutish forms of life; you will be able, through your own decision, to rise again to the superior orders, whose life is divine.

Pico della Mirandola

San Marco

Basilica of San Marco
VENICE

The group of Gothic structures that crown the three facades of the Basilica was created between the end of the fourteenth century and the first ten years of the fifteenth century. It is the work of Tuscan and Venetian sculptors: the Lamberti and their workshop who were from Tuscany, and the Dalle Masegne circle from Venice. St. Mark is the patron saint of Venice.

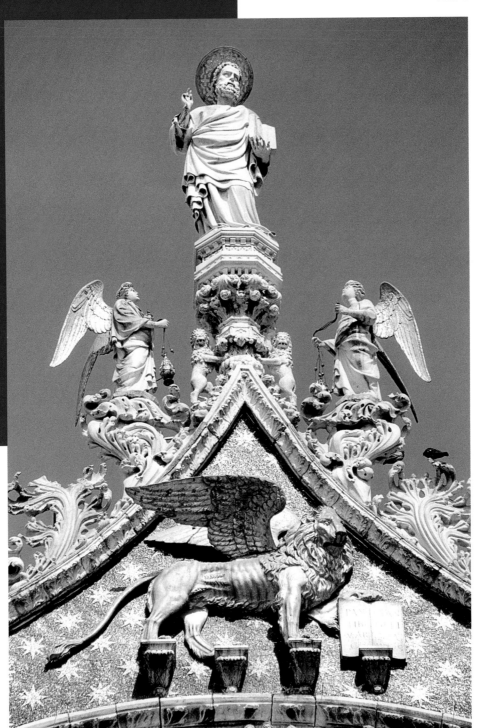

Shrine of the Holy Sepulchre (1467)

Leon Battista Alberti
Cappella Rucellai
San Pancrazio
FLORENCE

The small temple is in the fourteenth-century Rucellai Chapel, annexed to the church of San Pancrazio. This shrine was built in marble inlay as a funerary monument to Giovanni Rucellai. It was inspired by the Church of the Holy Sepulchre in Jerusalem, reinterpreted in a classic Renaissance style. The marble tiles, which decorate the exterior, are done in the Romanesque Florentine tradition, and each of these designs represents a heraldic emblem for important people of the time.

5

Anima Mundi

For Italian Renaissance philosophers, the *Anima Mundi,* the Soul of the World, was inseparable from the things of the world. The Divine Cosmos was a living, vibrating being, and everything in it was said to be created according to common principles. Although we know that ancient cultures the world over conceived of the interconnection between mathematical ratios, cosmology, and music, Pythagoras is the one credited with this discovery during the Classical Period of the Greco-Roman world. Pythagoras believed in the 'harmony of the spheres.' These harmonies were a mathematical concept which postulated the harmonious relationships of the distance between the planets and their rotations. Their movements were said to create a kind of music, inaudible to all but the most highly evolved beings.

These harmonic frequencies were also said to be reflected in the microcosm as a kind of internal music of the human body and in the sounds made by singers and instruments. In Raffaello's painting, *The School of Athens,* which depicts many of the Greek philosophers, Pythagoras is seated at the left, explaining the musical ratios to a student.

Plato, too, believed in the power of music to lift the soul. In the *Timaeus,* he speaks of the numerical, meaning also vibrational or musical, creation of the universe, and of the soul that enlivens it. He taught that through sacred song, the individual had the ability to reach these higher vibrations or frequencies.

Ficino wrote about this divine music, and about the poets and musicians who could sense it and become inspired to imitate it:

> *The soul receives the sweetest harmonies and numbers through the ears, and by these echoes is reminded and aroused to the divine music which may be heard by the more subtle and penetrating sense of mind. It is these who, inspired by the divine spirit, give forth with full voice the most solemn and glorious song.*

Ficino used astrological calculations, together with words and music, to employ 'natural' or spiritual magic. He believed that both musicians and listeners could become attuned with the rhythms of the cosmos by studying the properties and the movements of the planets and the stars, and by playing certain tones and intervals at beneficial times with the right intention. In addition, someone choosing the right time to create an image or prepare a medicine from plants or herbs could also attract favorable influences, and temper the negative influences, from the planets and stars.

Ficino wrote:

> *The Arabs say that when we fashion images rightly, our spirit, if it has been intent upon the work and upon the stars through imagination and emotion, is joined together with the very spirit of the world and with the rays of the stars through which the world-spirit acts.*

The harmonic principles of music and the divine order of the cosmos can be found in the proportions used in temple design, and undoubtedly those who constructed these places had reverence for the divine spirit of all creation. Throughout history,

architects have relied on mathematical principles to construct sacred spaces. Egyptian pyramids and Greek temples, for example, illustrate a balance and harmony of construction. Renaissance architects employed the divine ratio or the divine proportion that Roman architect Vitruvius used, based on the proportions of the human form. The divine proportion is a mathematical ratio defined by the number 'phi'—an irrational number with many unique qualities. It shows up in relationships throughout the universe, appearing in the bodies of other animals, in plants, in the solar system, and in music.

Renaissance architects, such as Brunelleschi, Alberti, Palladio, Michelangelo, and Bramante, conceived of mathematical plans using this sacred geometry. They employed ideals of symmetry and geometrical order, so that entering a building designed according to harmonious proportions could evoke a feeling of connection to a greater reality.

The ageless wisdom of a divine, interconnected universe found in the Hermetic and Kabbalistic writings, Pythagorean theory, and Platonic philosophy, and in the writings of Ficino and other philosophers, spread from the Medici court and the Platonic Academy out into the Renaissance world. It served as one of the strongest inspirations for the spiritual, artistic, and scientific innovations of the times.

In the centuries following the Renaissance, the philosophy of Ficino and the Platonic Academy, with its emphasis on the importance of the imagination, the individual's ability to intuit the truths of nature, and the power of Eros as a guiding force, continued to help shape the works of many European philosophers, writers, artists, and scientists. A pivotal figure in the dissemination of Neoplatonic knowledge was Paracelsus, the sixteenth-century Swiss medical theorist, doctor, alchemist, and writer, whose work served as a precursor to modern medicine and psychology.

In the sixteenth and seventeenth centuries, esoteric circles such as the Rosicrucians and Freemasons were also guided by ideas from Hermeticism, Kabbalah, and Neoplatonism. The nineteenth century saw the Theosophical

Movement of Helena Blavatsky and the Anthroposophy of Rudolf Steiner continue the belief in a Perennial Wisdom, accessible through direct experience. Also during the nineteenth century, Ralph Waldo Emerson, Henry David Thoreau, and others in the American transcendental movement championed the individual's gift of insight and the divinity of nature. Many of the transcendentalists, with their passion for the freedom of the individual and equality for all, became involved in antislavery and women's rights movements. Subsequently, the transcendentalists, especially Emerson, influenced the growth of the New Thought Movement and the development of such groups as Unity and Divine Science, which hold the belief that each person is an expression of the Divine.

In the early part of the twentieth century, we can find the continuation of Neoplatonic thought in Carl Jung's innovative work on archetypes, the collective unconscious, and alchemy as a psychological process; as well as in Joseph Campbell's writing on myth as a metaphor for our journey through life, with archetypes as powerful guiding forces within us. James Hillman and Thomas Moore, among others, have carried on, writing on archetypal psychology and the soul. Today, scholars continue to study and write on the Classical World and the Western esoteric tradition, particularly at the Warburg Institute at the University of London, the University of Exeter, UK, the University of Amsterdam, and the Sorbonne.

I believe that each of us can keep our connection with the Renaissance artists and philosophers who envisioned a way to live in harmony with all of life. We can continue to question established opinions, search for truth and beauty, and deepen our perception of the natural world. As individuals, we can use whatever talents we have been given by the stars to make our lives meaningful and useful, for ourselves, for other people, and for our planet. Finally, we can live in the knowledge that we are all part of a greater whole, a mysterious cosmos, that exists both outside of ourselves and in our hearts, minds, and souls, and which can reveal itself to us to the extent that we are receptive to its call.

Tempietto di San Pietro in Montorio
(CA. 1502)

Donato Bramante
ROME

This symbol of St. Peter's martyrdom stands in the cloister of San Pietro in Montorio. It is a kind of a shrine, which rises above an underground room said to contain the hole left by the cross on which Peter was crucified.

Inspired by ancient, classical temple design, Bramante used symmetry, proportion, and perspective to create one of the great masterpieces of the Renaissance.

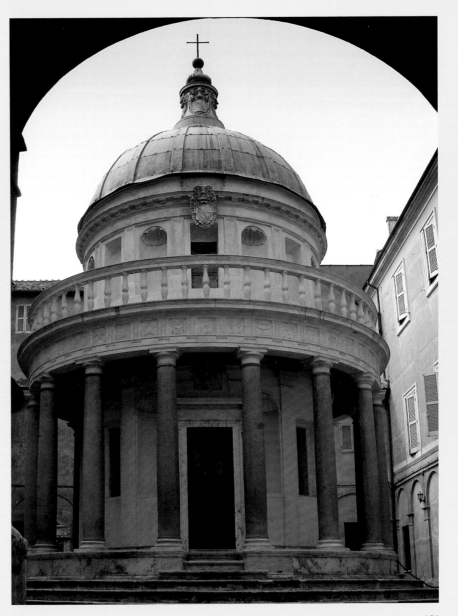

Beauty will derive from a graceful shape and the relationship of the whole to the parts, and of the parts among themselves and to the whole, because buildings must appear to be like complete and well-defined bodies, of which one member matches another and all the members are necessary for what is required.

Andrea Palladio

Il Redentore (BEGUN 1577)

Andrea Palladio
VENICE

The Redentore, whose full name, Chiesa del Santissimo Redentore, means Church of the Holy Redeemer, was built in thanks for the ending of a plague outbreak during 1575–1576, which killed more than 25 percent of the population of Venice. Every year thereafter, the ruling Doge of Venice and senators crossed a pontoon bridge from the Zattere to the island of Giudecca to attend a special Mass. The tradition is still celebrated by a festival on the third Sunday in July.

Marsilio Ficino

Dwell day by day in the open air for the longest time that it can be safely or conveniently done, in lofty, clear, and temperate regions. For thus the rays of the Sun and the stars touch you more readily and purely on all sides; and they fill your spirit with the spirit of the world shining forth more richly through their rays.

For Ficino, everything in nature was connected in one divine unity. To align ourselves both physically and spiritually with the greater powers of the cosmos, spending time in nature was essential. Ficino believed that the world lives and breathes, and that we can absorb the powers of the sun, the strongest celestial power that influences humans, by receiving its energy. In this way we, too, can become bright and strong.

The castle in the hill town of Urbino reflects the Renaissance ideal of harmonizing architecture with nature and seems to reach up to the heavens, with its every façade greeting the sun.

Palazzo Ducale and Duomo

URBINO

The Palazzo was designed primarily by Luciano Laurana in the sixteenth century, incorporating existing medieval structures. The adjacent Duomo was founded in the twelfth century and rebuilt in the fifteenth century. It was destroyed during an earthquake in the eighteenth century and again rebuilt.

One of the most important humanist centers during the Renaissance, Urbino was ruled by Federico da Montefeltro during the second part of the fifteenth century. Montefeltro employed the best artists and architects to build and decorate his palace. Castiglione's book, *The Courtier,* which describes fifteenth-century Italian court life, is set in the palace.

During life, the soul does leave its own body, but it cannot leave the universal body, nor can it be abandoned by the universal body, if you prefer to state it that way. For, when it leaves one simple or complex body . . . it goes to and enters another. Thus, it has an indissoluble connection with universal matter.

Giordano Bruno

Bruno believed in an infinite universe with a multiplicity of worlds, and in Divinity as being infused in all things. He also believed in reincarnation. This mosaic of the Wheel of Fortune was perhaps the earliest panel to be created for the floor.

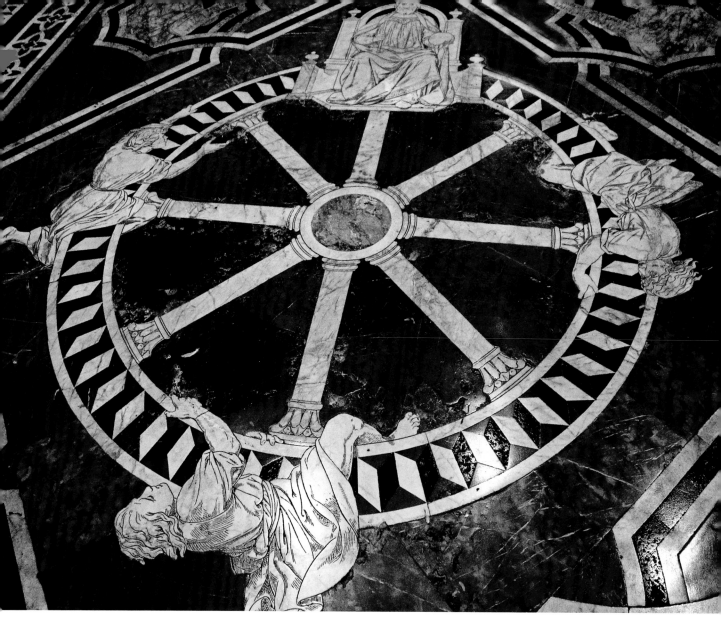

Wheel of Fortune (1372)

MOSAIC FLOOR, DETAIL

Siena Cathedral
SIENA

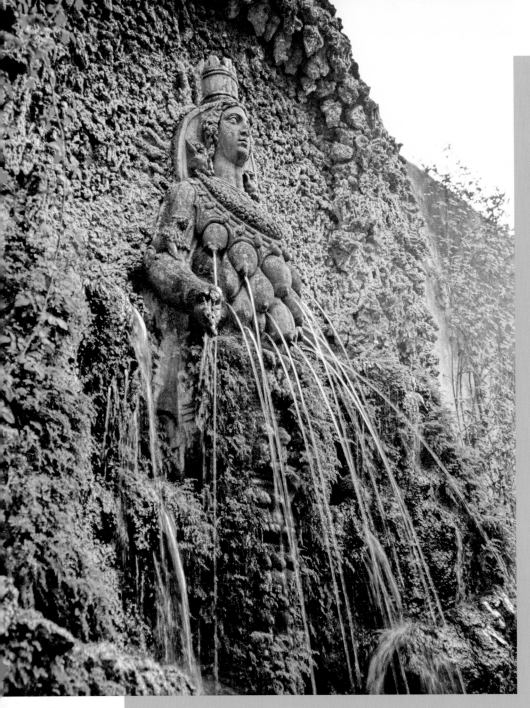

Diana of Ephesus
(CA. 1550)

**Symbolizing the
Great Mother
Villa d'Este
TIVOLI**

The fountain of Diana of
Ephesus has water flowing
from her numerous breasts,
symbolizing fertility and
abundance, both of nature
and of intellect. This goddess,
known as Artemis to the
Greeks, originated in Ephesus
in present-day Turkey, where
her sacred temple was once
one of the Seven Wonders
of the Ancient World.

Giordano Bruno

The spirits speak to us through visions and dreams, but we claim that these are enigmas, because of our unfamiliarity and ignorance and weak capacities, even though they are the very same sounds and very same expressions used for representable things.

Bruno took a fresh look at the human mind. He questioned and disputed established opinions, and his work demands that we examine our own dreams and visions and try to understand what they want to tell us.

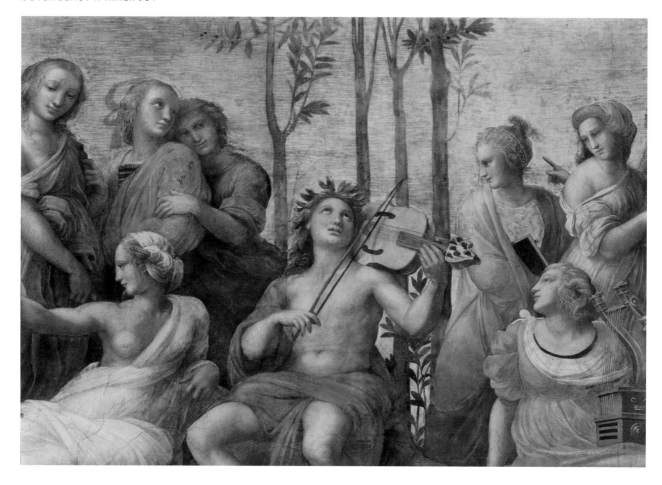

The Parnassus (1511)

DETAIL OF APOLLO AND THE MUSES

Raffaello
Stanza della Segnatura, Stanze di Raffaello
Vatican Palace
ROME

Parnassus is a mountain in central Greece that rises above Delphi, home of the most important oracle in ancient Greece, and sacred to Apollo, god of the sun, of light, of music, and the fine arts. The Muses are goddesses, who inspire the creation of art, music, and poetry. It was Apollo who gave Orpheus a lyre and taught him to play it. Here, Apollo is seen playing the Italian renaissance instrument, *lira da braccio*. Ficino, too, used a *lira da braccio*, calling it his 'Orphic lyre.'

The more noble and eminent spirits are said to be pleased by hymns, chants and musical instruments.

Giordano Bruno

Who could understand how all things, though different contingently, are the image of that single, infinite Form . . . ? The infinite Form is received only in a finite way; consequently, every creature is, as it were, a finite infinity or a created god, so that it exists in the way it could best be The inference, therefore, is that every created thing as such is perfect, even if in comparison to other things it seems less perfect. For the most merciful God communicates being to all in the manner in which it can be received.

Nicholas of Cusa

Cusa's words reflect the belief in the intrinsic value and divinity of all beings, however humble their lives and work may seem. Approaching the Piazza San Marco by sea, the vision of the clock tower and the Moors on top of it, who ring a bell on the hour, welcomed ancient mariners. It is one of the most important architectural landmarks in the city.

Torre dell'Orologio
(CLOCK TOWER) (1499)

Mauro Codussi
VENICE

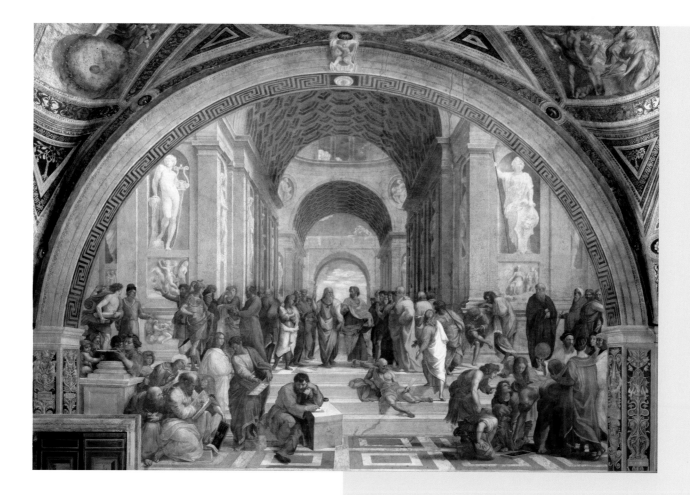

The School of Athens (1510-1511)

Raffaello
Stanza della Segnatura, Stanze di Raffaello
Vatican Palace
ROME

The School of Athens, commissioned by Pope Julius II for his papal apartments, is a painting of a spacious room, decorated with statues and reliefs, and filled with ancient wise men. Some have said that the building, which is in the shape of a Greek cross, illustrates a harmony between pagan philosophy and Christian theology. In the center, Aristotle points to the ground, illustrating his emphasis on the powers of observation to understand reality, while Plato points to the heavens, showing his mystical view.

Angelo Poliziano

When you concede that something actually exists in one or two people, you cannot deny that the potentiality exists throughout the entire human race.

One of the greatest scholars of the Renaissance, and a close friend of Marsilio Ficino and Pico della Mirandola, Poliziano urges us to discover within ourselves the best we have to offer. *The School of Athens,* with its panoply of ancient scholars, shows us some of the greatest minds in history. During the Renaissance, scholars followed their lead in their search for the truth, and universities such as Padua were founded, where distinguished students and teachers including Copernicus, Nicholas of Cusa, Giovanni Pico della Mirandola, and Galileo Galilei pursued their studies in freedom. Few of us can rise to the heights of these great thinkers, but they certainly can inspire us and lead the way.

Marsilio Ficino

Between the things that are purely eternal and those that are purely temporal is soul, a bond as it were linking the two.

Arriving just before closing time, the dim light, the purity, and the perfect proportions of the church interior gave me a feeling of unity and peace. Ficino wrote of the soul as immortal and divine. Because of this, he said, humans have the ability to be in contact directly with the Divine, and art could show us a resemblance of a higher world. This concept formed the basis of 'the dignity of man' of which Pico della Mirandola wrote, and which informed the writing and art of the period. In Ficino's greatest work, *Platonic Theology,* he sought to prove that the soul was indeed immortal and that there was a single source of the Judeo-Christian tradition and Greek philosophy.

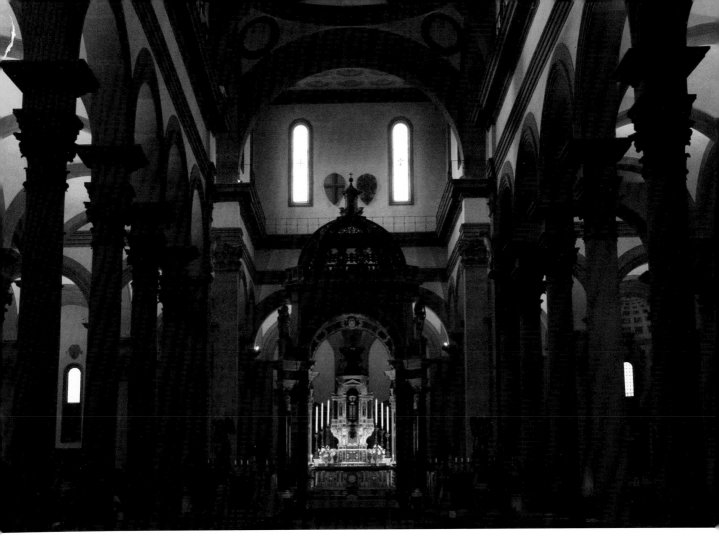

Santa Maria del Santo Spirito
(BEGUN IN 1434)

Filippo Brunelleschi
FLORENCE

The church interior, although altered by other architects after Brunelleschi's death, still contains the design innovations that he intended. A masterpiece of Renaissance architecture, it is a Latin cross plan with three aisles, thirty-eight niche chapels, and a Corinthian colonnade, which runs around the nave and the transept.

Leon Battista Alberti (1404–1472) | Because of the breadth of his works and knowledge, Alberti is considered the prototype of the Universal Man. A humanist, an architect, a linguist, a philosopher, and a theoretician, he gave a scientific basis to works of art. His writings include works on philosophy as well as on art and architecture. Among his best-known architectural works are: in Florence, Palazzo Rucellai and the Temple of San Sepulcro in the Rucellai Chapel; the façade of Santa Maria Novella; in Rimini, the Tempio Malatestiano.

Tullia d'Aragona (CA. 1508–1556) | Courtesan, author, and philosopher, D'Aragona lived in Siena, Rome, Venice, Ferrara, and Florence, where she became an attendant at the court of Cosimo I de Medici, Grand Duke of Tuscany.

Giuliano d'Arrigo, "Il Pesello" (1367–1446) | Florentine sculptor, painter, and architect who worked under Brunelleschi.

Ludovico Ariosto (1474–1533) | A diplomat and poet, Ariosto is best known for his epic poem *Orlando Furioso, Orlando Enraged.* It is a chivalric legend, a parody of medieval romances, and a monument to Italian Renaissance court society.

Giovanni Antonio Bazzi, known as Il Sodoma (1477–1549) | A painter with an elaborate and elegant style, Bazzi modeled his work on that of Leonardo. Bazzi painted mythological and religious subjects in Siena and Rome.

Pietro Bembo (1470–1547) | Born in Venice into an aristocratic family, Bembo was a humanist, poet, historian, and cardinal. His major works are *Gli Asolani,* a dialogue on courtly love, and *Prose della volgar lingua,* a book on poetry writing in Italian which helped to establish the modern Italian language.

Bartolomeo Bon (CA. 1400–CA. 1464) **Giovanni Bon** (CA. 1380–1442) | Sculptor and architect Bartolomeo Bon and his father Giovanni made great contributions to the Gothic style in Venice. Among their important works are the decoration of the Ca' D'Oro, commissioned by Marino Contarini, and the Porta della Carta at the Doge's Palace.

Sandro Botticelli (1445–1510) | Born in Florence, Botticelli painted in many genres, including altarpieces, small panel pictures, and devotional triptychs. In secular painting, four of Botticelli's most famous works are *Primavera, Pallas and the Centaur, Venus and Mars,* and the *Birth of Venus.* The meanings of the paintings, which continue to be discussed by scholars, are seen in the context of humanist poetry and philosophy. For Pope Sixtus IV, Botticelli was among a group of artists commissioned to fresco the walls of the Sistine Chapel.

Donato Bramante (CA. 1444–1514) | Bramante introduced the High Renaissance style in architecture. He contributed to the crypt and lower portions of the Cathedral in Pavia, and with Leonardo worked on the crossing tower of the Cathedral of Milan. Bramante was the planner for Pope Julius II's project to rebuild Rome.

Filippo Brunelleschi (1377–1446) | Brunelleschi is most celebrated for his famous dome, which he built for the Cathedral of Florence. A pioneer both as a painter and an architect, he is given credit for developing linear perspective, allowing Renaissance art to grow beyond the medieval stylized figures.

Giordano Bruno (1548–1600) | An astronomer, philosopher, mathematician, and former priest, Bruno believed in an infinite universe with a multiplicity of worlds and in divinity as being infused in all things. Accused of heresy, he fled Italy and lived in France and London where he wrote and published several books. When he returned to Italy, he was arrested by the Roman Inquisition. After being imprisoned for eight years, Bruno was burned at the stake.

Bernardo Buontalenti (CA. 1536–1608) | A stage designer and architect, Buontalenti came under the patronage of the Medici family where he remained for life. He designed new additions to some of their buildings as well as new residences and became renowned for his theatrical design.

Baldassare Castiglione (1478–1529) | Courtier, diplomat, and author, Castiglione is best known for his *Il Cortegiano, Book of the Courtier,* which describes the ideal court and courtier, or Renaissance gentleman, one who was educated in the classics.

Mauro Codussi (1440–1504) | One of the first Renaissance architects to employ the Classical style in Venice, Codussi's major works include the Church of San Zaccaria, San Michele in Isola, and Santa Maria Formosa.

Antonio da Correggio (1489–1534) | Born in Correggio near Reggio Emilia, Correggio is best known for his many works in Parma, especially his sweeping and mystical *Assumption of the Virgin* in the cupola of the Cathedral of Parma, and his painting *The Mystic Marriage of St. Catherine.*

Nicholas of Cusa (Nicolaus Cusanus) (1401–1464) Born in Germany, Cusa later studied canon law at the University of Padua. He was a cardinal and an ecclesiastical reformer, as well as a mathematician and astronomer. Learned in Neoplatonism and known for his spiritual writings, his work also influenced the development of mathematics and science.

Franceso Cattani da Diacceto (1466–1522) Diacceto studied philosophy at the University of Pisa along with Giovanni de' Medici, the future Pope Leo X. In the 1490s, he became a follower of Marsilio Ficino. Diacceto wrote a treatise on love in the vernacular entitled *I tre libri d'amore, The Three Books of Love,* and a philosophical treatment on beauty, *De pulchro.*

Leone Ebreo or **Hebreo (Judah Abravanel)** (1460–1521) | The son of a famous Portuguese philosopher, Bible commentator, and statesman, Ebreo was born on the Iberian Peninsula, and he practiced medicine as a physician in Lisbon. During the expulsion of the Jews in 1492, Ebreo and his family immigrated to Italy, where he continued to practice medicine in Naples and Genoa.

Andrea di Piero Ferrucci (1465–1526) | Born in Fiesole, Ferrucci worked in Florence and Naples. He served as the master builder at the Duomo in Florence from 1512 to 1526.

Marsilio Ficino (1433–1499) | Doctor, philosopher, theologian, astrologer, and linguist, Ficino was the most influential Neoplatonist of the Renaissance. Appointed head of the Platonic Academy in Careggi by Cosimo de' Medici, Ficino translated all of Plato's works into Latin, as well as works by other Greek philosophers, and the *Corpus Hermeticum* of Hermes Trismegistus. The most widely read of Ficino's own writings were *Platonic Theology, Three Books on Life,* which speak on health, astrology, and natural magic, and his *Commentary on Plato's Symposium on Love.*

Sebastiano Filippi (CA. 1532–1602) | Born in Ferrara, Filippi studied and worked with Michelangelo in Rome for seven years. In 1553 he returned to Ferrara where he painted in churches and in the Estense Castle. Here, he created frescoes with allegorical subjects in a Mannerist style.

Moderata Fonte (1555–1592) | Born in Venice and educated in the convent of Santa Marta, Fonte showed a remarkable aptitude for learning and memorization. She studied Latin and wrote her own poetry, dialogues, and dramatic allegories.

Veronica Franco (1546–1591) | A celebrated poet and courtesan, during the 1570s Franco was a member of the prestigious literary circle, the Accademia della Fama. She published two volumes, *Terze rime, Poems,* and *Lettere familiari a diversi, Familiar Letters to Various People.*

Taddeo Gaddi (CA. 1300–1366) | Painter and architect, Gaddi was an assistant to the great master Giotto di Bondone, and enjoyed a close and long-lasting relationship with him.

Galileo Galilei (1564–1642) | Known as the founder of science and of modern physics, Galileo was a physicist, mathematician, philosopher, and astronomer. His discoveries include the law of the motion of uniformly accelerated objects, and the four largest satellites of Jupiter. He made improvements to the telescope, and he published an account of his observations, arguing in favor of the sun-centered Copernican theory. Forced by the Inquisition to recant his theory of heliocentrism, he spent the last years of his life under house arrest.

Cristofano Gherardi (1508–1556) | A late Renaissance painter in the Tuscan-Roman Mannerist style, Gherardi worked on frescoes in Perugia and Bologna. He worked closely with Giorgio Vasari for many years, and in 1554, he and Vasari collaborated on the frescoes in the Apartment of the Elements in the Palazzo Vecchio.

Lorenzo Ghiberti (1378–1455) | Born in Florence, Ghiberti is best known for works in sculpture and metalworking. In 1401 he won a competition to create the first set of bronze doors for the Baptistery of St. John in Florence, containing 28 panels with scenes from the New Testament. These were completed in 1427. Thereafter he was commissioned to create another set with scenes from the Old Testament, made up of 10 rectangular panels, called the 'Gates of Paradise,' completed in 1452.

Giambologna (Jean Boulogne) (1529–1608) | Born in Flanders (now France) Giambologna studied in Rome and was influenced by the work of Michelangelo. He was the preeminent sculptor in the Mannerist style in Italy during the last quarter of the sixteenth century.

Luciano Laurana (1420–1479) | Born near Croatia, part of the Venetian empire at the time, Laurana was active in Italy. He is best known for his work on the Palazzo Ducale in Urbino, where he designed the innovative façade. He also worked with Leon Battista Alberti in Mantua, and on the Castle, or Rocca, in Pesaro.

Pirro Ligorio (CA. 1513–1583) | An architect, scholar, painter, and garden designer, Ligorio worked under Popes Pius IV and Paul IV overseeing the excavations of ancient monuments in Rome. He also worked on the excavations of Hadrian's Villa at Tivoli and designed the water features at the Villa d'Este.

Filippo Lippi (1406–1469) | Lippi was a Carmelite friar and later held various church posts. He was particularly recognized for his paintings of the Madonna, several of which are at the Uffizi Gallery in Florence. The Medici were his patrons, and Botticelli was his student.

Antonio Lombardo (CA. 1458–1516) | In Venice, where he was born, Lombardo contributed to the churches of Santa Maria dei Miracoli, San Giobbe, and San Giovanni e Paolo, and in Padua to the Church of Saint Anthony. In Ferrara, he entered the service of Duke Alfonso I, and he has been acclaimed for his reliefs based on mythological themes created for the ducal palace.

Andrea Mantegna (1431–1506) | A painter and engraver and a master of perspective and foreshortening, Mantegna was one of the key figures in the art of the second half of the sixteenth century. In Padua he worked in the Ovetari Chapel in the Eremitani Church, using *di sotto in su* or "from above so below" perspective, in which spatial effects are used to create the illusion of a three dimensional space. In 1459 he became the court painter to the Gonzaga family in Mantua.

Lorenzo de' Medici, il Magnifico (1449–1492)
Known during his lifetime as Lorenzo the Magnificent, Lorenzo was grandson of Cosimo de' Medici, founding father of the Medici dynasty, and son of Piero. Lorenzo studied Greek, Latin, and philosophy with Marsilio Ficino as his tutor. He ruled the Florentine Republic from 1469 to 1492. A great patron of artists, he was also a poet and expanded the Laurentian Library, which his grandfather had begun. Following in his grandfather's footsteps, he supported the Platonic Academy and the scholarly work of Ficino and Pico della Mirandola.

Michelangelo (Michelangelo di Lodovico Buonarotti Simoni) (1475–1564) | One of the greatest artists of all times, Michelangelo was a painter, sculptor, architect, and poet. Along with Leonardo da Vinci, he is considered the personification of a Renaissance Man *par excellence.* The chapel of the Medici and the statue of *David* in Florence, the dome of St. Peter's in Rome and the *Pietà* within it, and the frescoes of *Genesis* and the *Last Judgment,* in the Vatican's Sistine Chapel, are today some of his most famous works. As a youth, Michelangelo studied at a school run by Lorenzo de' Medici where he was influenced by Platonic philosophy.

Michelozzo (Michelozzo di Bartolomeo) (1396–1472) Michelozzo, a sculptor and architect, studied and worked with Ghiberti on the golden doors of the Baptistery of the Florence Cathedral. He also collaborated with Donatello on the pulpit in the Prato cathedral. His principal patrons were the Medici, and he remained close to them throughout his career. Michelozzo was an innovator in the Renaissance design of the Florentine Palazzo.

Giralomo Muziano (1532–1592) | A draftsman and painter, Muziano was active mainly in Rome, where he was a leading artist during the 1570s and 1580s. He based his painting on the style of Michelangelo, focusing on the anatomy of his figures.

Andrea Palladio (1508–1580) | Considered one of the most influential people in the development of Western architecture, Palladio was particularly influenced by Roman and Greek architecture, and the writings of Vitruvius. His work is also linked to the traditions of Alberti and Bramante in the use of art and forms relating to nature. All of his buildings are located in Northern Italy, and Vicenza is today known as the 'City of Palladio and the Palladian Villas of the Veneto.' In 1570 he published *I Quattro Libri dell'Architettura, The Four Books of Architecture.* It was translated widely in Europe and is in print to this day.

Francesco Petrarca (1304–1374) | Known as the 'father of Humanism,' and, along with Dante, 'father of the Renaissance,' Petrarca was a scholar and poet, the foremost contributor to the formation of the modern Italian language. Petrarch polished and perfected the sonnet form for his poems to Laura, an idealized beloved, and the Petrarchan sonnet bears his name. Named poet laureate in Rome, and crowned with a laurel wreath on the Capitoline Hill in 1341, he was the first to be awarded this honor since ancient times.

Giovanni Pico della Mirandola (1463–1494) | Born near Ferrara of noble birth, Pico studied Canon law at the University of Bologna and later attended the University of Ferrara and the University of Padua. He learned Greek, Latin, Arabic, and Hebrew, and studied the Kabbalah with renowned Jewish scholars. In Florence, he became a member of the Platonic Academy and was a close friend of Marsilio Ficino and Angelo Poliziano. Towards the end of his life, he became a follower of the anti-humanist Dominican monk, Savonarola.

Pinturicchio (CA. 1452–1513) | Bernardino di Betto, known as Pinturicchio, was born in Perugia. In Rome, he decorated the Borgia Apartments for Pope Alexander VI. In Siena, in the library adjoining the Siena Cathedral,

he painted a fresco depicting scenes from the life of Humanist Aeneas Silvius Piccolomini (Pope Pius II), and designed a mosaic floor panel: the Story of Fortuna, or the Hill of Virtue.

Bonifacio de' Pitati (1487-1553) | Born in Verona, de' Pitati ran a workshop in Venice. He was influenced by Giorgione and Tiziano. His work is in museums around the world.

Angelo Poliziano (Angelo Ambrogini) (1454-1494) Foremost classical scholar and poet of the Renaissance, Poliziano was born in Montepulciano but sent to Florence as a boy where he began to study Latin and Greek. Lorenzo de' Medici became his patron, taking Poliziano into his household as a tutor to his son Piero, and later arranging a post for him at the University of Florence. Poliziano was a member of the Platonic Academy and a close friend to both Marsilio Ficino and Pico della Mirandola. He translated many texts from the Greek, and also wrote verses in Latin, Greek, and Italian.

Raffaello (Rafaello Sanzio) (1483-1520) | Born in Urbino, Raffaello is grouped with Michelangelo and Leonardo as one of the three master artists of the Italian High Renaissance. He arrived in Florence in about 1504, where his principal teachers were Leonardo and Michelangelo. In 1508 he was called to Rome by Pope Julius II, and remained there for the rest of his life. Pope Julius II commissioned him to fresco his private library at the Vatican Palace. The Stanze della Segnatura, or Raphel's Rooms, contain the artist's greatest works: *The School of Athens, The Parnassus,* and *The Disputa.*

Lucca della Robbia (1400-1482) | Born in Florence, della Robbia is known for developing a pottery glaze that gave his works durability on the exterior of buildings. He collaborated with both Filippo Brunelleschi and Lorenzo Ghiberti. An important work of della Robbia is the marble *Cantoria, Singing Gallery,* for the organ loft of Florence Cathedral, a masterpiece of the naturalistic Renaissance style.

Giulio Romano (CA. 1499-1546) | Painter and architect during the late Renaissance, Romano's style helped define the school of Mannerism. He was a student and assistant of Raffaello, and when Raffaello died became his principle heir, completing some of the artist's unfinished work. In Mantua, Romano enjoyed the patronage and friendship of the duke, Federico II Gonzaga.

Cosimo Rosselli (1439-1507) | Active mainly in Florence, Rosselli also worked on the Sistine Chapel. With assistants, he painted scenes from the life of Christ, the *Sermon on the Mount* and the *Last Supper,* as well as other biblical scenes.

Antonio Rossellino (1427-CA. 1479) | Born in Florence, Rossellino probably studied under Donatello. His carvings and reliefs are extremely realistic, and he is known for his many works of the Madonna.

Jacopo Sansovino (1486-1570) | A sculptor and architect, Sansovino was born in Florence. He later studied ancient architecture and sculpture in Rome. After the Sack of Rome in 1527, he moved to Venice and in 1529 he became the chief architect and superintendent of properties to the Procurators of San Marco.

Andrea del Sarto (1486-CA. 1530) | One of Florence's most highly regarded Mannerist painters, del Sarto was a collaborator on frescoes for the Santissimia Annunciata. He also painted an altarpiece for the Convent of San Francesco dei Macci, *Madonna of the Harpies,* now in the Uffizi Gallery.

Vincenzo Scamozzi (1548-1616) | Scamozzi, a Venetian architect and writer, worked closely with Andrea Palladio and completed projects begun by Palladio that were left unfinished at his death. Among other projects, he designed the Procuratie Nuove at Piazza San Marco in Venice. His treatise, *L'Idea della Architettura Universale, The Idea of Universal Architecture,* was an important Renaissance work on the theory of architecture.

Lodovico Settevecchi (CA. 1520-1590) | Born in Modena, Settevecchi developed as an artist in Ferrara. He collaborated several times with Sebastiano Filippi, and was the most original and important of those who worked under him in the decoration of the piano nobile of the Estense Castle for Alfonso II d'Este.

Giovanni Stradano (Jan van der Straet or Stradanus) (1523-1605) | Born in Flanders, Stradano moved to Italy in about 1546. After spending time in Rome and in Florence, from 1557 on he served the Medici Dukes. He assisted Giorgio Vasari in the Palazzo Vecchio.

Laura Bacio Terracina (1519-CA. 1577) | Born in Naples into a noble family, Terracina published eight volumes of poetry. She was the most prolific woman poet of the sixteenth century. All her life, she acted on her belief in women's need to succeed artistically.

Tintoretto (Jacopo Robusti Tintoretto) (1518-1594) Born in Venice where he remained for his entire life, Tintoretto was one of the greatest painters of the late Renaissance as well as one of the most prolific. Some of his most well-known works are in the Scuola Grande di San Rocco, a major religious confraternity of Venice. He also painted many works for the Doge's Palace.

Tiziano (Tiziano Vecellio) (1490-1576) | The greatest painter of the Venetian school, in 1516, Tiziano became the official painter of the Republic of Venice and maintained that position for 60 years. His subject matter included religious, mythological, and portrait paintings. One of his best-known works, and the one which established his reputation, is *Assumption of the Virgin* in the church of Santa Maria dei Frari. His unrestrained and dramatic brushwork transformed oil technique and influenced countless artists who came after him.

Giorgio Vasari (1511-1574) | A painter, architect, and writer, Vasari received his training in Florence where he was taken under the patronage of the Medici. Along with a team of assistants, he painted the fresco cycles in the Palazzo Vecchio. He is best known for his book *Le Vite de' più eccellenti architetti, pittori, et scultori italiani, Lives of the Most Eminent Painters, Sculptors, and Architects.*

Paolo Veronese (Paolo Caliari) (1528-1588) | Born in Verona, hence the name 'Veronese,' Paolo Veronese was one of the three great painters active in sixteenth-century Venice along with Tiziano and Tintoretto. Veronese painted many religious scenes with the characters in Venetian clothing and settings, and he is known as a master of color. He created works for churches and refectories, the Doge's Palace, and the Marciana Library in Venice, and for the Villa Barbaro in Maser. Two of his most famous works are the *Wedding at Cana* and the *Feast in the House of Levi.*

Leonardo da Vinci (1452-1519) | Born near Florence, the illegitimate son of a notary and a peasant girl, Leonardo da Vinci, one of history's great geniuses, epitomized the term 'Renaissance Man.' Among his talents and pursuits he was a writer, a musician, a mathematician, an engineer, an inventor, an anatomist, an architect, and a painter. His two most famous paintings, the *Mona Lisa* and the *Last Supper,* continue to be widely copied and reproduced. Few of his paintings survive. His notebooks containing drawings, writings, and diagrams are a legacy of unsurpassed value to artists who followed him.

Giovanni Battista Zelotti (1526-1578) | Born in Verona, Zelotti trained with Paolo Veronese, and he worked with him on several projects, including the ceiling of the Room of the Council of Ten in the Doge's Palace and in the Marciana Library in Venice. Some of his most important work was carried out in villas in the Veneto.

ADDITIONAL SELECTED BIBLIOGRAPHY

Aromatico, Andrea. *Alchemy, The Great Secret.* New York: Discoveries, Harry N. Abrams Publishers, 1996.

Atchity, Kenneth J., Editor, Rosemary Mckenna, Assistant Editor. *The Renaissance Reader.* New York: HarperCollins Publishers, 1996.

Benevolo, Leonardo. *The Architecture of the Renaissance,* Volume 1. Translated by Judith Landry. London: Routledge, 2002.

Blech, Benjamin and Roy Doliner. *The Sistine Secrets: Unlocking the Codes in Michelangelo's Defiant Masterpiece.* London: JR Books, 2008.

Bull, Malcolm. *The Mirror of the Gods: How Renaissance Artists Rediscovered the Pagan Gods.* London and New York: Oxford University Press, 2005.

Burckhardt, Jacob. *The Civilization of the Renaissance in Italy.* New York: Barnes & Noble Books, 1999.

Burke, Peter. *The Italian Renaissance, Culture and Society in Italy.* Princeton, New Jersey: Princeton University Press, 1999.

Cheney, Liana de Girolami. "Sala degli Elementi in Palazzo Vecchio: The Symbolism of Water." Discoveries 26.2. December 29, 2009. http://cstlcla.semo.edu/reinheimer/discoveries/articles/articleCheney262.shtml

D'Aragona, Tullia. *Dialogue on the Infinity of Love.* Edited and Translated by Rinaldina Russel and Brucy Merry. London and Chicago: The University of Chicago Press, 1997.

Deimling, Barbara. *Botticelli.* Köln: Taschen, 2004.

Ebreo, Leone. *The Philosophy of Love (Dialoghi D'Amore).* Translated into English by F. Friedeberg-Seeley and Jean H. Barnes, with an Introduction by Cecil Roth. London: The Soncino Press, 1937.

Ficino, Marsilio. *The Book of Life: A Translation by Charles Boer of Liber de Vita (or De Vita Triplici).* Woodstock, Connecticut: Spring Publications, 1996.

_____. *Meditations on the Soul-Selected Letters of Marsilio Ficino.* Translated from the Latin by members of the Language Department of the School of Economic Science, London. Rochester, Vermont: Inner Traditions, 1996.

Godwin, Joscelyn. *The Pagan Dream of the Renaissance.* Grand Rapids, MI: Phanes Press, 2002.

Gollnick, James. *Love and the Soul: Psychological Interpretations of the Eros and Psyche Myth.* Waterloo, Ontario, Canada: Wilfrid Laurier UP, 1992.

Goodrick-Clarke, Nicholas. *The Western Esoteric Traditions: A Historical Introduction.* Oxford: Oxford University Press, 2008.

Hillman, James. *Re-Visioning Psychology.* New York: HarperCollins, 1992.

Impelluso, Lucia. *Gods and Heroes in Art.* Edited by Stefano Zuffi. Translated by Thomas Michael Hartmann. Los Angeles: Getty Publications, 2003.

Jacobi, Jolande. *Complex/Archteype/Symbol in the Psychology of C.G. Jung.* London: Routledge, 1999.

Johnson, Paul. *The Renaissance: A Short History.* New York: Modern Library, a division of Random House, 2002.

Johnson, Robert A. *Ecstasy: Understanding the Psychology of Joy.* New York: HarperCollins, 1989.

Lefaivre, Liane and Alexander Tzonis. *The Emergence of Modern Architecture: A Documentary History from 1000 to 1810.* London: Routledge, 2004.

Moore, Thomas. *Care of the Soul: A Guide for Cultivating Depth and Sacredness in Everyday Life.* New York: HarperCollins, 1992.

_____. *The Planets Within: The Astrological Psychology of Marsilio Ficino* (Studies in Imagination Series). Hudson, New York: Associated University Presses, 1982.

O'Brien, Elmer, Translator. *The Essential Plotinus: Representative Treatises from the Enneads,* Selected and Translated with Introduction and Commentary by Elmer O'Brien, S.J. Indianapolis, IN: Hackett Publishing Company, 1964.

Petrarch, Francis. *My Secret Book.* Translated by J.G. Nichols. London: Hesperus Press, 2002.

Plato. *Great Dialogues of Plato.* Translated by W.H. D. Rouse, Edited by Erik H. Warmington and Philip G. Rouse. New York: New American Library, 1956.

Plumb, J.H. *The Italian Renaissance.* Boston: The American Heritage Library, Houghton Mifflin Company, 1989.

Remes, Pauliina. *Neoplatonism.* Berkeley and Los Angeles: University of California Press, 2008.

Robin, Diana, Anne R. Larsen, and Carol Levin. *Encyclopedia of Women in the Renaissance: Italy, France, and England.* Santa Barbara, CA: ABC-CLIO, 2007.

Saur, K.G. *The Artists of the World: Bio-Bibliographical Index by Profession.* Munich: Saur, 2002.

Seznec, Jean. *The Survival of the Pagan Gods: The Mythological Tradition and Its Place in Renaissance Humanism and Art.* Translated from the French by Barbara F. Sessions. Princeton, N.J.: Princeton University Press, 1972.

Smoley, Richard and Jay Kinney. *Hidden Wisdom: A Guide to the Western Inner Traditions.* Wheaton, Illinois: Quest Books, 2006.

Strohmeier, John and Peter Westbrook. *Divine Harmony, The Life and Teachings of Pythagoras.* Berkeley, CA: Berkeley Hills Books, 1999.

Thoenes, Christof. *Raphael.* Köln: Taschen, 2005.

Vasari, Giorgio. *The Lives of the Artists.* Translated by Julia Conaway and Peter Bondanella. New York: Oxford University Press, 1998.

Voss, Angela, Editor. *Western Esoteric Masters Series: Marsilio Ficino.* Berkeley, California: North Atlantic Books, 2006.

_____. "The Natural Magic of Marsilio Ficino." *Historical Dance,* Volume 3, Number 1, 25-30, 1992. Dolmetsch Historical Dance Society, 1992. www.dhds.org.uk/jnl/pdf/hd3n1p25.pdf

Wertheim, Margaret. *Pythagoras' Trousers: God, Physics, and the Gender Wars.* New York: W.W. Norton and Company, 1997.

Wind, Edgar. *Pagan Mysteries in the Renaissance.* New York: W. W. Norton and Company, 1968.

Wittkower, Rudolf and Margot. *Born Under Saturn: The Character and Conduct of Artists: A Documentary History from Antiquity to the French Revolution.* New York: New York Review of Books, 2007.

Yates, Frances A. *Giordano Bruno and the Hermetic Tradition.* Chicago and London: The University of Chicago Press, 1964.

Zorzi, Marino. *La Libreria di San Marco: Libri, lettori, societa' nella Venezia dei Dogi.* Milano: Arnoldo Mondadori Editore, 1987.

QUOTATION SOURCES

FRONT MATTER

"An enchanted life has many moments . . ."
Thomas Moore, *The Re-Enchantment of Everyday Life* (New York: HarperCollins Publishers, 1996), ix.

"Regaining the memory . . ."
Marsilio Ficino, *Meditations on the Soul: Selected Letters of Marsilio Ficino,* trans. Members of the Language Department of the School of Economic Science, London (Rochester, Vermont: Inner Traditions International, 1996), 66.

" . . . cultivated a concrete world full of soul . . ."
Thomas Moore, *Care of the Soul* (New York: HarperPerennial, 1994), 281.

"Here, visitor, is Marsilio . . ."
Marino Zorzi, trans., Inscription, Church of Santa Maria del Fiore, Florence.

"Divine Providence brought our world . . ."
Plato, *Timaeus,* trans. Donald J. Zeyl (Indianapolis, IN: Hackett Publishing Company, 2000), 16.

"I saw the angel in the marble . . ."
Michelangelo Buonarotti
http://www.michelangelomodels.com/m-models/m_poems.html

"If we are to call any age golden . . ."
Marsilio Ficino, "Extract from a letter to Paul Middleburg," quoted in June Osborne, *Urbino, The Story of a Renaissance City* (Chicago: The University of Chicago Press, 2003), 14.

CHAPTER ONE

True, without error, certain and most true . . .
Hermes Trismegistus, "The Smaragdine Table" from *Divine Pymander,* ed. Paschal Beverly Randolph (Rosicrucian Publishing Co., 1871, reprinted: Des Plaines, Illinois: Yogi Publication Society), 21.

"At every person's birth . . ."
Marsilio Ficino, *De vita libri tres, Three Books on Life, A Critical Edition and Translation,* ed. and trans. Carol V. Kaske and John R. Clark (Tempe, Arizona: Arizona Center for Medieval and Renaissance Studies in conjunction with The Renaissance Society of America, 2002), 370. Julianne Davidow trans. this quote.

"If you are born . . ."
Marsilio Ficino, *De vita libri tres, Three Books on Life,* 370. Thomas Moore trans. this quote.

"The whole universe . . ."
Leone Hebreo, *Dialoghi di Amore* (Di Nuovo Corretti et Ristampati in Vinegia, Appresso Domenico Giglio, 1558), 103. Julianne Davidow trans. this quote.

"Interaction occurs . . ."
Giordano Bruno, from *On Magic,* ed. and trans. Richard J. Blackwell, found in *Cause, Principle and Unity and Essays on Magic* (Cambridge Texts in the History of Philosophy), ed. and trans. Richard J. Blackwell and Robert de Lucca (Cambridge, U.K: Cambridge University Press, 1998), 115.

"Oh friends, live freely and uninhibitedly . . ."
Marsilio Ficino, *De vita libri tres, Three Books on Life,* 404. Julianne Davidow trans. this quote.

"Visible light depends on invisible light . . ."
Marsilio Ficino, *Platonic Theology,* Volume 2: Books V–VIII (The I Tatti Renaissance Library), English trans. Michael J.B. Allen with John Warden; Latin text ed. James Hankins with William Bowen (Cambridge, Massachusetts and London: Harvard University Press, 2002), 155.

"Every production of whatever kind . . ."
Giordano Bruno, from *Cause Principle and Unity,* ed. and trans. Robert de Lucca, found in *Cause, Principle and Unity and Essays on Magic,* 90.

"Man should devote all his energies . . ."
Moderata Fonte, *The Worth of Women,* ed. and trans. Virginia Cox (Chicago: The University of Chicago Press, 1997), 128.

CHAPTER TWO

"Beauty is a true image of the godhead."
Francesco Cattani da Diacceto, from "Panegyric on Love," *Cambridge Translations of Renaissance Philosophical Texts Volume I: Moral Philosophy,* ed. Jill Kraye (Cambridge, U.K.: Cambridge University Press, 1997), 158.

"These celestial bodies . . ."
Marsilio Ficino, *Meditations on the Soul: Selected Letters of Marsilio Ficino,* 167.

"Painting possesses a truly divine power . . ."
Leon Battista Alberti, *On Painting,* trans. Cecil Grayson (London: Penguin Books, 1972), 60–61.

"The relationship of art to nature . . ."
Marsilio Ficino, *Platonic Theology Volume I, Books I–IV* (The I Tatti Renaissance Library), English trans. Michael J.B. Allen with John Warden, Latin Text ed. James Hankins with William Bowen (Cambridge, Massachusetts and London, 2002), 139.

"Where the spirit does not work . . ."
Leonardo da Vinci
http://www.quotedb.com/quotes/3071

"The more the marble wastes . . ."
Michelangelo Buonarotti, from John Bartlett's *Familiar Quotations,* Justin Kaplan, general ed. (Boston: Little, Brown, 1992), 137.

"The true work of art . . ."
Michelangelo Buonarotti
http://www.greatest-inspirational-quotes.com/inspirational-art-quotes.html

"The things formed by nature . . ."
Giordano Bruno, *Cause, Principle and Unity,* 57.

"Beauty arouses our soul . . ."
Francesco Cattani da Diacceto, from "Panegyric on Love," *Cambridge Translations of Renaissance Philosophical Texts, Volume 1: Moral Philosophy,* 157.

CHAPTER THREE

"Why do we think love is a magician . . ."
Marsilio Ficino, *Commentary on Plato's Symposium on Love,* 127.

"He who properly uses love . . ."
Ibid., 54.

"Notice how Solomon . . ."
Baldessare Castiglione, *The Book of the Courtier* (London: Penguin Books, 1967), 257.

"Cupid is shown naked . . ."
Leone Hebreo, *Dialoghi di Amore,* 34. Julianne Davidow trans. this quote.

"There are two ways to love . . ."
Tullia D'Aragona, "Dialogo della Signora Tullia D'Aragona Della Infinita di Amore," from *Trattati D'Amore del Cinquecento, A Cura di Giuseppe Zonta* (Bari: Bius, Laterza & Figli, Tipografi-Editori-Librai, 1912), 222. Julianne Davidow trans. this quote.

"So sweet and delicious do I become . . . "
Veronica Franco, *Poems and Selected Letters*, ed. and trans. Ann Rosalind Jones and Margaret F. Rosenthal (Chicago and London: The University of Chicago Press, 1998), 69.

"When a man has amorous concourse . . . "
Moderata Fonte, *The Worth of Women*, ed. and trans. Virginia Cox (Chicago: The University of Chicago Press, 1997), 90.

"If the same ardor, the same urge . . . "
Ludovico Ariosto, *Orlando Furioso* (The World's Classics) trans. Guido Waldman (New York: Oxford University Press, 1983), Canto 4, 66.

"It is immensely important . . . "
Francesco Cattani da Diacceto, from "Panegyric on Love," *Cambridge Translations of Renaissance Philosophical Texts, Volume 1: Moral Philosophy*, 163.

"Virtuous love is not merely . . . "
Pietro Bembo, from "Gli Asolani," *The Italian Renaissance* (Renaissance Society of America) ed. Werner L. Gundersheimer, (Canada: University of Toronto Press, 1993), 140.

"Love, your beauty is not a mortal thing . . . "
Michelangelo Buonarotti, *The Poetry of Michelangelo: An Annotated Translation*, ed. and trans. James M. Saslow (New Haven and London: Yale University Press, 1991), 133.

"However long the soul intently stares . . . "
Lorenzo de' Medici, *Selected Poems and Prose*, ed. Jon Thiem, trans. Jon Thiem and Others (University Park, Pennsylvania: The Pennsylvania State University Press, 1991), 83.

CHAPTER FOUR

"We can say that the earth . . . "
Leonardo da Vinci, *Literary Works*, ed. J.P. Richter, Oxford, 1929, no. 1000, quoted in Peter Burke, *The Italian Renaissance: Culture and Society in Italy* (Princeton: Princeton University Press, 1999), 205.

"A man will never become a philosopher . . . "
Galileo Galilei, *Discoveries and Opinions of Galileo*, trans. Stillman Drake (Garden City, New York: Doubleday Anchor, 1957), 225.

"One cannot have greater lordship . . . "
Leonardo da Vinci, *Prophecies and other Literary Writings*, trans. J.G. Nichols (London: Hesperus Press Limited, 2002), 39.

"He who harms others . . . "
Ibid., 45.

"All emotions are related to the soul . . . "
Angelo Poliziano, from "Letter to Bartolomeo Scala in Defense of the Stoic Philosopher Epictetus," *Cambridge Translations of Renaissance Philosophical Texts, Volume I: Moral Philosophy*, 195.

"If only women would give up their needles . . . "
Laura Bacio Terracina, *Women Poets of the Italian Renaissance: Courtly Ladies & Courtesans*, ed. Laura Anna Stortoni, trans. Laura Anna Stortoni and Mary Prentice Lillie (New York: Italica Press, 1997), 111.

"Many may be brought to profess . . . "
Francesco Petrarca, *The Life of Solitude*, trans. Jacob Zeitlin (Urbana: University of Ilinois Press, 1924; Westport: Hyperion Press, 1978), 139.

"Any school which attacks . . . "
Pici Mirandulensis Oratio de Hominis Dignitate. http://www.thelatinlibrary.com/mirandola/oratio.shtml, Nos. 203 and 204. Julianne Davidow trans. this quote.

"You may, as the free and proud shaper . . . "
Giovanni Pico della Mirandola, *Oration on the Dignity of Man*, trans. A. Robert Caponigri (Washington, D.C.: A Gateway Edition, Regenery Publishing, 1956; [1999 printing]), 7-8.

CHAPTER FIVE

"The soul receives the sweetest harmonies . . . "
Marsilio Ficino, *Meditations on the Soul*, 67.

"The Arabs say . . . "
Marsilio Ficino, *Three Books on Life*, 351.

"Beauty will derive from a graceful shape . . . "
Andrea Palladio, *The Four Books on Architecture*, trans. Robert Tavernor and Richard Shofield (Cambridge: MA: The MIT Press, 2002), 7.

"Dwell day by day in the open air . . . "
Marsilio Ficino, *Three Books on Life*, 291.

"During life, the soul does leave . . . "
Giordano Bruno, *On Magic*, 116.

"The spirits speak to us . . . "
Ibid., 115.

"The more noble and eminent spirits . . . "
Giordano Bruno, *On Magic*, 128.

"Who could understand how all things . . . "
Nicholas of Cusa, *Selected Spiritual Writings*, trans. H. Lawrence (Mahwah, New York: Paulist University Press, 1997), 134.

"When you concede . . . "
Angelo Poliziano, "A letter to Bartolomeo Scala in Defense of the Stoic Philosopher Epictetus," *Cambridge Translations of Renaissance Philosophical Texts, Volume I: Moral Philosophy*, 196.

"Between the things . . . "
Marsilio Ficino, *Platonic Theology*, Volume I, Books I-IV, 233.

PHOTO CREDITS

COVER

Vasari, Giorgio (1511-1574) and
Gherardi, Cristofano (1508-1556)
Allegory on Water: Birth of Venus.
1555.
Location: Apartment of the Elements,
Palazzo Vecchio, Florence
Photo Credit: Julianne Davidow

FRONT MATTER

Botticelli, Sandro (1444-1510)
Madonna of the Magnificat. Ca. 1485.
Detail of Virgin Mary.
Location: Uffizi, Florence, Italy
Photo Credit : Erich Lessing /
Art Resource, NY

Zelotti, Giovanni Battista (1526-1578)
Venus and Cupid. Ca. 1542.
Location: Room of Olympus, Villa Godi,
designed by Andrea Palladio.
Vicenza, Italy
Photo Credit: Julianne Davidow

Botticelli, Sandro (1444-1510)
La Primavera. The Three Graces.
Ca. 1482. Detail of 40-07-01/60.
Tempera on wood,
203 x 314 cm. Inv. 8360.
Location: Uffizi, Florence, Italy
Photo Credit: Erich Lessing /
Art Resource, NY

Botticelli, Sandro (1444-1510)
The Birth of Venus. 1486.
Detail of head of Venus.
Tempera on canvas.
Location: Uffizi, Florence, Italy
Photo Credit: Erich Lessing /
Art Resource, NY

Basilica San Miniato al Monte (ext.)
Location: Florence, Italy
Photo Credit: Julianne Davidow

Basilica San Miniato al Monte (int.)
Location: Florence, Italy
Photo Credit: Julianne Davidow

Rosselli, Cosimo (1439-1507)
**Pico della Mirandola, Marsilio Ficino
and Poliziano.** 1484-86. Detail at center
of the Miracle of the Sacrament. Fresco.
Location: S. Ambrogio, Florence, Italy
Photo Credit: Scala/Art Resource, NY

Botticelli, Sandro (1444-1510)
Madonna of the Magnificat. Ca. 1483.
Detail of angels.
Tempera on wood.
Diameter: 46 1/2 in. (118 cm).
Location: Uffizi, Florence, Italy
Photo Credit: Scala/Art Resource, NY

Ferrucci, Andrea di Piero (1465-1526)
Bust of Marsilio Ficino. 1521.
Location: Basilica of Santa Maria
del Fiore, Florence, Italy
Photo Credit: Julianne Davidow

Michelozzo (1396-1472)
Villa Medici di Careggi.
Location: Florence, Italy
Photo Credit: Julianne Davidow

Palladio, Andrea (1508-1580)
Church of San Giorgio Maggiore.
1559-1580.
Location: Venice, Italy
Photo Credit: Julianne Davidow

Buonarroti, Michelangelo (1475-1564)
David. 1501-1504. Marble. Post-
restoration.
Location: Accademia, Florence, Italy
Photo Credit: Scala/Ministero per i Beni e
le Attività culturali/Art Resource, NY

**The River Arno and the Bridges
of Florence.**
Location: Florence, Italy
Photo Credit: Julianne Davidow

CHAPTER ONE

Hermes Trismegistus. 1482.
Detail, mosaic floor.
Location: Siena Cathedral, Siena, Italy
Photo Credit: Scala/Art Resource, NY

da Vinci, Leonardo (1452-1519).
Vitruvian Man. Ca. 1492. Drawing.
Photo Credit: Scala/Art Resource, NY
Accademia, Venice, Italy

Filippi, Sebastiano (ca. 1532-1602); and
Settevecchi, Ludovico (Ca. 1520-1590)
**Allegory of 'Day,' The Chamber of
Dawn, Apartment of the Mirror.**
Location: The Estense Castle, Ferrara, Italy

Pitati, Bonifacio de' (1487-1553)
The Labours of the Months: July.
Early sixteenth century. Oil on canvas,
13.3 x 10.2 cm. Layard Bequest, 1916
(NG3110.1). Location: National Gallery,
London, Great Britain
Photo Credit: © National Gallery,
London/Art Resource, NY

Stradano, Giovanni (1523-1605)
The Alchemist. 1570.
Location: Studiolo, Palazzo Vecchio,
Florence, Italy
Photo Credit: Scala/Art Resource, NY

Palladio, Andrea (1508-1580); completed
by Scamozzi, Vincenzo (1548-1616)
Teatro Olimpico. 1579-1584.
Location: Vicenza, Italy
Photo Credit: Julianne Davidow

Muziano, Girolamo (1532-1592)
and Associates
Synod of the Gods. Begun in 1565
Ceiling fresco, Hall of the Fountain,
Villa D'Este. Location: Tivoli, Italy
Photo Credit: Julianne Davidow

Certosa di Pavia. Begun in 1396.
Location: Pavia, Italy
Photo Credit: Julianne Davidow

Antonio Rossellino (1427-ca. 1479)
Tomb of the Cardinal of Portugal.
1461-1466.
Location: Basilica San Miniato al Monte,
Florence, Italy
Photo Credit: Julianne Davidow

Da Correggio, Antonio (1489-1534)
The Assumption of the Virgin. 1530.
Location: Parma Cathedral, Parma, Italy
Photo Credit: Julianne Davidow

CHAPTER TWO

Veronese, Paolo (1528-1588)
Perseus and Andromeda. ca. 1580.
Canvas, 260 x 211 cm.
Location :Musee des Beaux-Arts,
Rennes, France
Photo Credit : Erich Lessing /
Art Resource, NY

Sansovino, Jacopo (1486-1570)
Scala dei Giganti. 1554-1556.
Location: Doge's Palace, Venice, Italy
Photo Credit: Julianne Davidow

Passarotti, Bartolomeo (1529-1592)
Jupiter. Pen & ink, charcoal; 44.1 x 38.1
cm. Photo: Thierry le Mage. (Inv. 8463)
Location : Louvre, Paris, France

Giambologna (1529-1608)
Perseus from the Oceanus Fountain.
Location: Boboli Gardens, Florence, Italy
Photo Credit: Julianne Davidow

da Vinci, Leonardo (1452-1519).
Head of a Maiden. Ca. 1508.
Drawing. Photo: George Tatge, 2000.
Location: Galleria Nazionale, Parma, Italy
Photo Credit: Alinari/Art Resource, NY

Buonarroti, Michelangelo (1475-1564)
One of four Prisoners
Grotta Grande, designed by Buontal enti.
Ca. 1536-1608.
Location: Boboli Gardens, Florence, Italy
Photo Credit: Julianne Davidow

Buonarroti, Michelangelo (1475-1564)
Rondanini Pietà. 1555-1564.
Location: Castello Sforzesco (Sforza
Castle), Milan, Italy
Photo Credit: Julianne Davidow

Buonarroti, Michelangelo (1475-1564)
Pietà. 1498-1499. Marble.
Photo: G. Cigolini
Location: St. Peter's Basilica, Vatican State
Photo Credit : © DeA Picture Library /
Art Resource, NY

Buonarroti, Michelangelo (1475-1564)
Moses. 1513-1515.
Location: Church of San Pietro in Vincoli,
Rome, Italy
Photo Credit: Julianne Davidow

Giusti Gardens
Location: Verona, Italy
Photo Credit: Julianne Davidow

Lippi, Filippo (1406-1469)
Madonna and Child.
Location: Palazzo Medici Riccardi,
Florence, Italy
Photo Credit: Scala/Art Resource, NY

CHAPTER THREE

Botticelli, Sandro (1444-1510)
La Primavera (Spring). 1477.
Tempera on wood, 203 x 314 cm.
Location: Uffizi, Florence, Italy
Photo Credit: Erich Lessing /
Art Resource, NY

Ghiberti, Lorenzo (1378-1455)
Solomon and the Queen of Sheba
Detail of The Gates of Paradise of the
Baptistery of St. John. 1452.
Location: Florence, Italy
Photo Credit: Julianne Davidow

Titian (Tiziano Vecellio) (ca. 1488-1576)
Mars, Venus, and Amor. 1560.
Oil on canvas. 97 x 109 cm. Inv. 13.
Location: Kunsthistorisches Museum,
Vienna, Austria
Photo Credit : Erich Lessing /
Art Resource, NY

Titian (Tiziano Vecellio) (ca. 1488-1576)
Amor Sacro and Amor Profano.
Ca. 1515.
Location: Galleria Borghese, Rome, Italy
Photo Credit: Alinari/Art Resource, NY

Romano, Giulio (ca. 1499-1546)
Cupid and Psyche. 1525-1535.
Location: Palazzo Te, Mantua, Italy
Photo Credit: Julianne Davidow

Romano, Giulio (ca. 1499-1546)
Fresco. 1525-1535. Detail.
Location: Palazzo Te, Mantua, Italy
Photo Credit: Julianne Davidow

Mantegna, Andrea (1431-1506)
Parnassus, Mars and Venus. 1496.
Oil on canvas, 160 x 192 cm.
Location: Louvre, Paris, France
Photo Credit: Erich Lessing /
Art Resource, NY

Bazzi, Giovan Antonio (1477-1549)
Wedding of Roxana and Alexander.
Ca. 1517.
Location: Sala di Sodoma (also known
as Agostino's bedroom), Villa Farnesina,
Rome, Italy
Photo Credit: Julianne Davidow

Tintoretto, Jacopo Robusti (1518-1594)
**Ariadne meeting Bacchus and
Crowned by Venus.** 1576.
Oil on canvas, 148 x 168 cm.
Sala dell'Anticollegio
Location: Palazzo Ducale, Venice, Italy
Photo Credit: Cameraphoto Arte, Venice/
Art Resource, NY

Buonarroti, Michelangelo (1475-1564)
Ignudo. 1508-1512.
Detail of the Sistine ceiling.
Location: Sistine Chapel, Vatican Palace,
Vatican State
Photo Credit: Scala/Art Resource, NY

Raphael (Raffaello Sanzio) (1483-1520)
The vision of the prophet Ezekiel.
1518. Wood, 40 x 30 cm. INV 174.
Location: Galleria Palatina, Palazzo Pitti,
Florence, Italy
Photo Credit: Erich Lessing /
Art Resource, NY

CHAPTER FOUR

Lombardo, Antonio (ca. 1458-1516)
**The contest between Minerva and
Neptune for the possession of
Attica.** 1508.
Location: The Estense Castle, Ferrara,
Italy

Campanile (Bell Tower).
Sixteenth century.
Location: Venice, Italy
Photo Credit: Julianne Davidow

Giambologna (1529-1608)
Colossus of the Appenine. 1581.
Location: Villa Demidoff, Pratolino, Italy
Photo Credit: Julianne Davidow

Giambologna (1529-1608)
Rape of the Sabine Women. 1579-83.
Location: Loggia dei Lanzi, Florence, Italy
Photo Credit: Julianne Davidow

Buonarroti, Michelangelo (1475-1564)
Piazza del Campidoglio. 1538.
Replica of Roman statue of
Marcus Aurelius.
Location: Rome, Italy
Photo Credit: Julianne Davidow

Sarto, Andrea d'Agnolo, del
(1486-ca. 1530)
**Portrait of a girl with the "Petrarchi-
no", a small edition of poems
by Petrarch.** Ca. 1514.
Wood, 87 x 69 cm INV. 783
Location: Uffizi, Florence, Italy
Photo Credit: Erich Lessing/
Art Resource, NY

Pinturicchio, Bernardo (ca. 1452-1513)
**Pope Pius II (Aeneas Piccolomini)
Canonizes Catherine of Siena.**
1502-1508.
Portraits of Raffaello and Pinturicchio,
Location: Piccolomini Library, Siena
Cathedral, Siena, Italy
Photo Credit: Julianne Davidow

The Great German Scola.
Ashkenazi synagogue. 1528-29.
Location: Venice, Italy
Photo Credit: Julianne Davidow

Lamberti workshop and Dalle
Masegne circle
San Marco. Early fifteenth century.
Detail of the Basilica of San Marco.
Location: Venice, Italy
Photo Credit: Julianne Davidow

CHAPTER FIVE

Alberti, Leon Battista (1404-1472)
Shrine of the Holy Sepulchre. 1467.
Cappella Rucellai, San Pancrazio
Location: Florence, Italy
Photo Credit: Julianne Davidow

Bramante, Donato (ca. 1444-1514)
Tempietto di San Pietro in Montorio.
Ca. 1502.
Location: Rome, Italy
Photo Credit: Julianne Davidow

Palladio, Andrea (1508-1580)
Il Redentore. 1577.
Location: Venice, Italy
Photo Credit: Julianne Davidow

Laurana, Luciano (1420-1479)
Palazzo Ducale and Duomo
Location: Urbino, Italy
Photo Credit: Julianne Davidow

Wheel of Fortune. 1372.
Detail, mosaic floor.
Location: Siena Cathedral, Siena, Italy
Photo Credit: Julianne Davidow

**Diana of Ephesus, Symbolizing the
Great Mother**
Location: Villa d'Este, Tivoli, Italy
Photo Credit: Julianne Davidow

Raphael (Raffaello Sanzio) (1483-1520)
The Parnassus. 1511.
Detail of Apollo and the Muses.
Location: Stanza della Segnatura, Stanze di
Raffaello, Vatican Palace, Vatican State
Photo Credit : Scala / Art Resource, NY

Codussi, Mauro (1440-1504)
Torre dell'Orologio, Clock Tower. 1499.
Location: Piazza San Marco, Venice, Italy
Photo Credit: Julianne Davidow

Raphael (Raffaello Sanzio) (1483-1520)
The School of Athens. Ca. 1510-1520.
Fresco.
Location: Stanza della Segnatura, Stanze di
Raffaello, Vatican Palace, Vatican State
Photo Credit: Scala/Art Resource, NY

Brunelleschi, Filippo (1377-1446)
Santa Maria del Spirito Santo.
Begun 1434.
Location: Florence, Italy
Photo Credit: Julianne Davidow